DR

STRONGER

SELF-CARE FOR
CARTOONISTS & VISUAL ARTISTS

"There is an Artist's Angel! I keep her vital, helpful advice within arm's reach by my drawing board... and, she's the only angel I have ever met named Kriota Willberg."
——ARNOLD ROTH, **Humbug, The New Yorker, etc.**

"Easy-to-understand anatomical drawings flesh out basic descriptions of repetitive stress injury, tendonitis, and muscle spasms. Along with plenty of caveats about when to seek out a doctor, Willberg offers basic stretches, exercises, and lifestyle tips (along with dad-joke humor) to ease the aches and pains of modern-day, desk-bound creative careers. This practical, handy volume is a worthy addition to many workplace bookshelves—preferably high up, requiring a standing stretch to reach it."
——**PUBLISHERS WEEKLY**

"As a cartoonist who has clenched my tools, had what I thought was carpal tunnel and tennis elbow, and then had neck surgery, I can't tell you how much I wish Willberg's book had existed 20 years ago. It would have helped me understand what was going on in my body and all the different ways to address the stress that we artistes put ourselves through every day. Her drawings and explanations are clear, and the exercises and stretches she provides are essential for anyone who sits hunched over their computer or tablet all day. This morning I did one of her cartoonist workout routines and already I feel better! As a teacher of aspiring cartoonists, I will make *Draw Stronger* mandatory for them all."
——LAUREN WEINSTEIN, **Normel Person (Village Voice)**

Uncivilized Books
P. O. Box 6534
Minneapolis, MN 55406
USA
uncivilizedbooks.com

Third Edition, May 2020

11 10 9 8 7 6 5 4 3

ISBN 978-1-9412502-3-5

DISTRIBUTED TO THE TRADE BY:
Consortium Book Sales & Distribution, LLC.
34 Thirteenth Avenue NE, Suite 101
Minneapolis, MN 55413-1007
cbsd.com
Orders: (800) 283-3572

Printed in USA

KRIOTA WILLBERG

DRAW
STRONGER

SELF-CARE FOR
CARTOONISTS & VISUAL ARTISTS

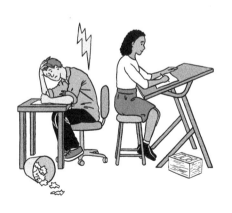

UNCIVILIZED BOOKS, PUBLISHER

Thank you
Greg Byers, DPT
MK Czerwiec, RN, MA
Glenna Lampner, CSCS
William Rahner
for reviews, corrections, and suggestions!

This book would not have been possible
without James Sturm, Michelle Ollie, and
the students and faculty at the Center for
Cartoon Studies, thanks for the inspiration!

Thank you to my students and my patients who
teach me something new every day.

Heidi MacDonald and Tom Kaczynski, thanks for
being advocates for healthy drawing.

Complaints regarding my sense of humor
should be directed to Arnold Roth whose
Crazy Book Of Science has been my
companion since my 12th birthday.

For R.

What
about
ME?

CONTENTS

Who is This Book For?

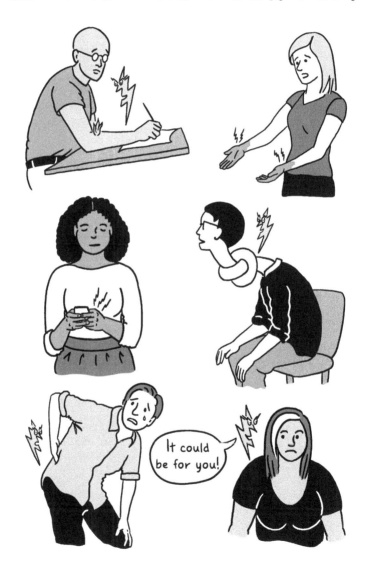

WHO IS THIS BOOK FOR?
THIS BOOK IS FOR YOU IF...

YOU SWEAR YOU ARE NOT GOING TO USE THIS
MANUAL IN PLACE OF MEDICAL ADVICE...

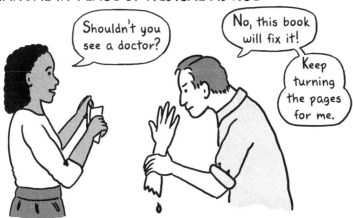

AND YOU'RE A HEALTHY* PERSON EXPERIENCING
OCCASIONAL PAIN WHILE DRAWING...

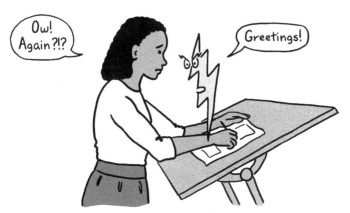

*How do you know if you're "healthy"? Consult your doctor before
beginning any exercise plan, including this one!

OR YOU'VE MADE AN APPOINTMENT TO SEE A **QUALIFIED HEATHCARE PROVIDER,** BUT THEY CAN'T SEE YOU RIGHT AWAY AND YOU WANT TO DO SOMETHING **NOW...**

OR YOU WANT TO LEARN SOME SELF CARE TIPS FOR **INJURY PREVENTION** AND **PAIN MANAGEMENT.**

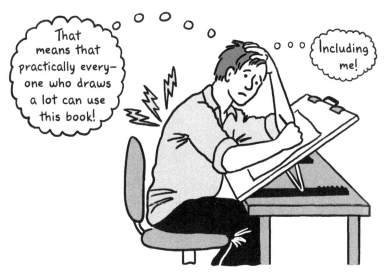

Pain is Your Frenemy

Pay attention to your pain.

PAIN IS YOUR *FRENEMY*

PAIN IS TRYING TO **TELL *YOU* SOMETHING.**

IF YOU IGNORE IT...

IT WILL TRY **HARDER** AND **HARDER**...

TO GET YOUR **ATTENTION.**

TRY TO **UNDERSTAND** YOUR **PAIN.**
SURE PAIN IS **OBNOXIOUS**, BUT IT **TELLS** YOU THAT
SOMETHING NEEDS **TAKING CARE OF.**

WHAT MAKES IT **BETTER?** WHAT MAKES IT **WORSE?**

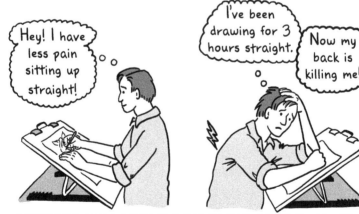

WHEN DO YOU GET IT? **WHAT** KIND OF PAIN IS IT?
HOW INTENSE IS IT? KNOWING THESE ANSWERS,
CHANGING BAD HABITS, AND **EXERCISING** MAY
HELP **PREVENT** FUTURE **PAIN.**

HEALTHCARE PROS WILL **ASK** YOU ABOUT YOUR **PAIN**. OFTEN THEY WILL ASK YOU TO **RATE ITS INTENSITY**. UNDERSTANDING THE **SEVERITY** OF YOUR PAIN CAN HELP YOU MAKE **DECISIONS** ABOUT **CARING FOR YOURSELF**.

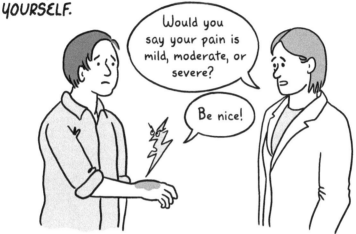

EVERYONE EXPERIENCES PAIN **DIFFERENTLY** AND WILL **DESCRIBE** IT IN DIFFERENT WAYS.

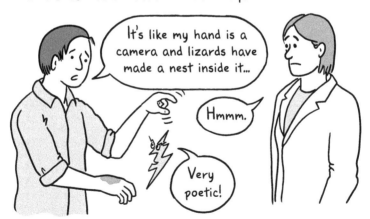

HEALTHCARE PROFESSIONALS HAVE DESIGNED DIFFERENT **PAIN SCALES** TO HELP PEOPLE **FIND A COMMON LANGUAGE** FOR THEIR PAIN.

PAIN SCALES

THE FIRST THREE **PAIN SCALES** BELOW ARE OFTEN USED IN HEALTHCARE SETTINGS.

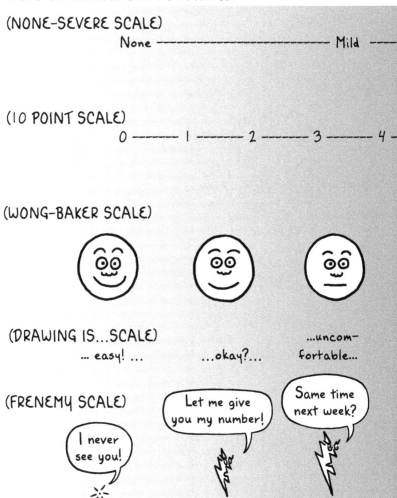

(NONE—SEVERE SCALE)

None ———————————————————— Mild ————

(10 POINT SCALE)

0 ——————— 1 ——————— 2 ——————— 3 ——————— 4 —

(WONG—BAKER SCALE)

(DRAWING IS...SCALE)

... easy!okay?... ...uncom-
 fortable...

(FRENEMY SCALE)

Let me give you my number!

Same time next week?

I never see you!

PAIN THAT **INTERRUPTS** YOUR DRAWING PRACTICE INFLUENCES YOUR **MOOD**, AND/OR MAKES YOUR DAILY LIFE **DIFFICULT**...

THE LAST TWO HAVE BEEN **MADE UP** (BY THE AUTHOR).

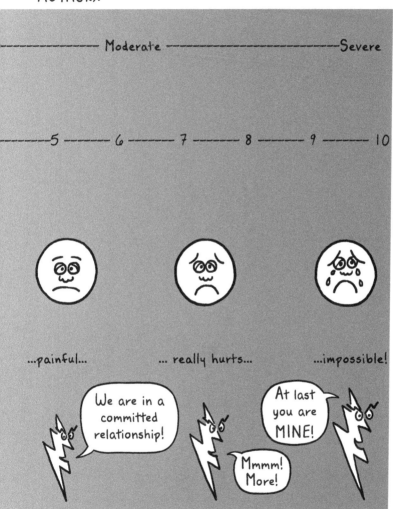

DESERVES THE **ATTENTION** OF A **QUALIFIED HEALTHCARE PRACTITIONER.**

Do I Need To See A Doctor?

Here are some guidelines to help you answer this question.

IF THE **WORST** HAPPENS AND YOU BEGIN TO EXPERIENCE SOME KIND OF ARM, NECK, OR BACK **PAIN**, HOW DO YOU KNOW WHETHER OR NOT TO SEE A DOCTOR?

FIRST, IF YOU THINK YOU SHOULD SEE A DOCTOR— **YOU SHOULD SEE A DOCTOR!**

DON'T WORRY ABOUT FEELING LIKE A WIMP.

IF YOU'RE **NOT SURE** WHETHER OR NOT TO CONSULT A **QUALIFIED HEALTHCARE PRACTITIONER**, THIS REFERENCE LIST MAY BE A USEFUL GUIDELINE.

GET MEDICAL ATTENTION OR SEE A QUALIFIED PRACTITIONER FOR YOUR PAIN IF—

YOU ARE IN INTENSE **PAIN**.

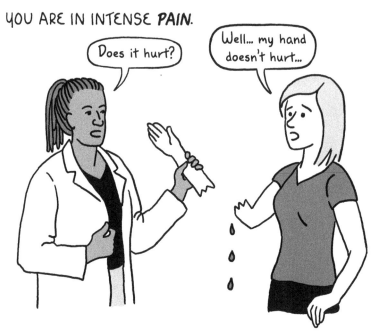

YOU EXPERIENCE...

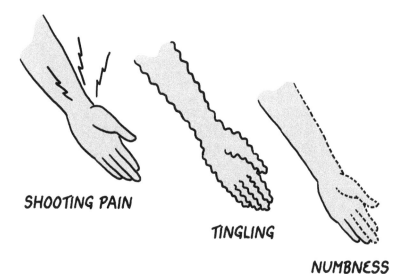

SHOOTING PAIN

TINGLING

NUMBNESS

THE CONDITION **FAILS TO IMPROVE** WITHIN **3–5 DAYS**.

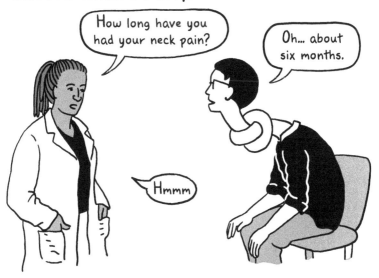

YOU CAN'T DRAW OR HOLD A PENCIL COMFORTABLY.

MONDAY'S DRAWING

TUESDAY'S DRAWING

WEDNESDAY'S DRAWING

THERE IS **DISCOLORATION** AND/OR EXCESSIVE **BRUISING**.

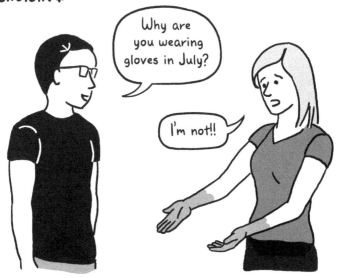

THERE IS **DEFORMITY** AND/OR EXCESSIVE **SWELLING**.

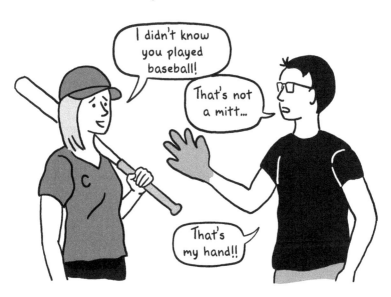

THE CONDITION **CONTINUES TO GET WORSE.**

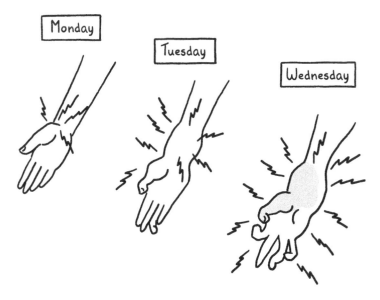

THERE WAS AN **ACCIDENT** AND YOU MAY HAVE WHIPLASH, HIT YOUR HEAD, SPRAINED A JOINT, OR FRACTURED A BONE.

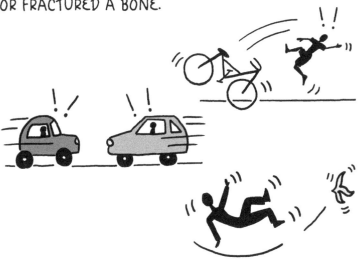

WHAT IS A **"QUALIFIED HEALTH PRACTITIONER"**? SOMEONE **LEGALLY** AND **EDUCATIONALLY** QUALIFIED TO **DIAGNOSE** YOUR INJURY. SCOPE OF PRACTICE CHANGES FROM STATE TO STATE, BUT THIS PERSON IS MOST LIKELY...

A **DOCTOR** SPECIALIZING IN ORTHODPEDICS, OSTEOPATHY, SPORTS MEDICINE, OR NEUROLOGY. IF YOU DON'T KNOW WHO TO GO TO, YOU CAN START WITH YOUR REGULAR DOCTOR. OR YOU MIGHT WANT TO SEE...

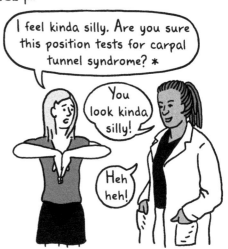

*The slightly embarrassing Phalen's test (above) is a standard manuever, making this joke very funny to orthopedists!

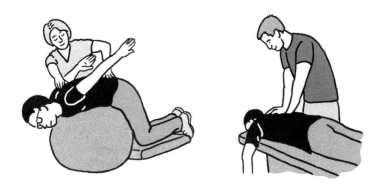

A **PHYSICAL THERAPIST** OR A **CHIROPRACTOR.**

ON THE OTHER HAND...
MASSAGE THERAPISTS, ACUPUNCTURISTS,

PILATES INSTRUCTORS, AND OTHER BODY- OR
ENERGY- WORKERS...

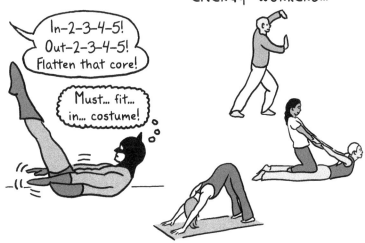

CAN **TREAT** YOU, BUT THEY CAN'T **DIAGNOSE** YOU!

Types of Injuries Caused by Repetitive Activities

(Like drawing, inking, coloring, computer work, research, texting, sitting, everything...!)

REPETITIVE STRESS INJURY
(a.k.a REPETITIVE STRAIN INJURY, RSI, AND/OR OVERUSE SYNDROME)

RSI IS CAUSED BY **REPEATED** USE AND **OVERLOAD** OF A BODY PART, RESULTING IN **INJURY** TO THE AREA. OVERUSE CAN COME FROM A VARIETY OF ACTIVITIES AND AFFECT DIFFERENT PARTS OF THE BODY.

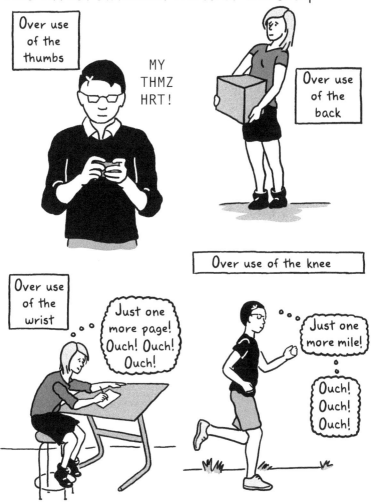

ANATOMY OF MUSCLE, TENDON AND SOME INJURIES

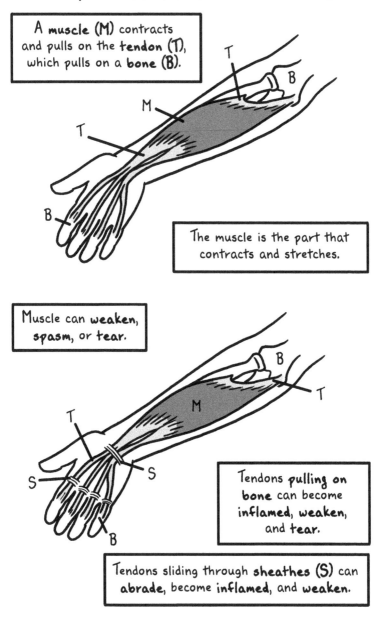

A **muscle (M)** contracts and pulls on the **tendon (T)**, which pulls on a **bone (B)**.

The muscle is the part that contracts and stretches.

Muscle can **weaken**, **spasm**, or **tear**.

Tendons **pulling on bone** can become **inflamed, weaken,** and **tear**.

Tendons sliding through **sheaths (S)** can **abrade**, become **inflamed**, and **weaken**.

THE ROTATOR CUFF

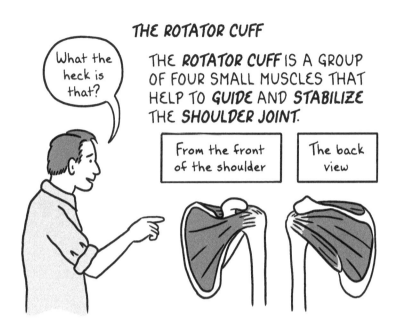

THE **ROTATOR CUFF** IS A GROUP OF FOUR SMALL MUSCLES THAT HELP TO **GUIDE** AND **STABILIZE** THE **SHOULDER JOINT.**

POOR POSTURE AND **FORWARD SHOULDERS** CAN LEAD TO **STRESS** ON THESE MUSCLES AND CAUSE **PAIN** WHILE DRAWING.

OVERUSE OF THESE MUSCLES CAN LEAD TO **SPASM,** **STRAIN,** OR **TENDINITIS.** (LIKE OTHER MUSCLES.)

TYPES OF RSIS

THERE ARE MANY NAMES FOR TENDON DAMAGE*.
OVER-WORKING A WEAK TENDON IS ONE WAY TO
INJURE AND INFLAME IT. HERE ARE SOME EXAMPLES:

Trigger finger – affects the sheath surrounding the thumb or finger flexor tendons on the palm.

DeQuervain's Tenosynovitis – affects the thumb tendons at the side of the wrist.

* Tendinitis, tendinosis, and tenosynovitis, to name a few.

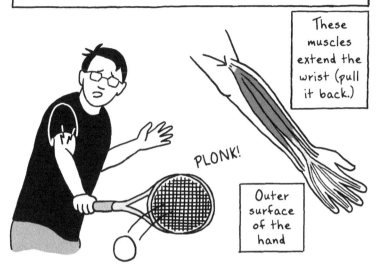

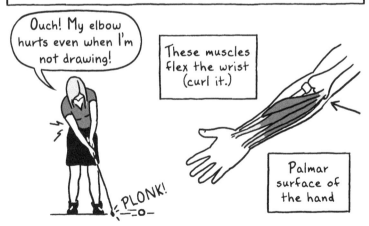

LONG HOURS OF DRAWING COULD RESULT IN ANY OF THESE TENDINITISES, -OSISES, AND TENOSYNOVITISES.

SYMPTOMS OF TENDON INJURY

1. **PAIN.** SOMETIMES "BURNING."

2. **WEAKNESS.**

3. MUSCLE AND TENDON **TIGHTNESS.**

4. SOMETIMES– –THERE'S **SWELLING...** OR **NOT.**

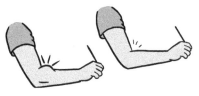

–SYMPTOMS ARE **SEVERE...** OR **NOT.**

MUSCLE STRAIN

MUSCLE STRAIN OCCURS WHEN MUSCLE CELLS ARE **OVERSTRETCHED**...

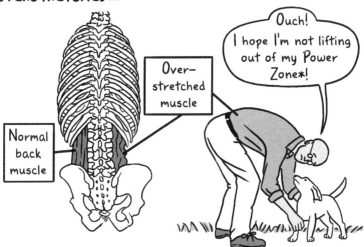

OR **TORN**. THIS IS CAUSED BY **OVERLOADING** THE MUSCLE. (WITH OR WITHOUT OVERSTRETCH.)

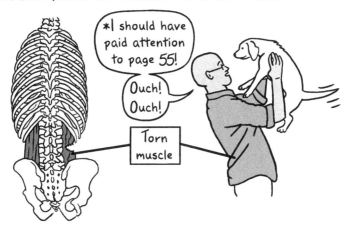

BAD POSTURE, POSITION, AND/OR **HEAVY LOAD** CAN LEAD TO **OVERSTRETCH** OR **TEARING** OF MUSCLES IN YOUR **BACK**, OR **SOMEWHERE ELSE!**

MUSCLE SPASM

STRESSED, OVERWORKED, AND/OR FATIGUED MUSCLES CAN GO INTO **SPASM**.

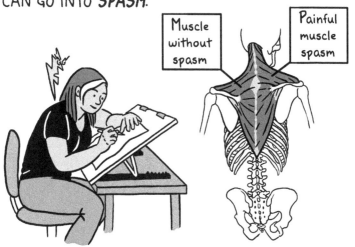

SPASMS ARE ALSO CALLED **"KNOTS."** THESE CAN BE VERY PAINFUL BY THEMSELVES...

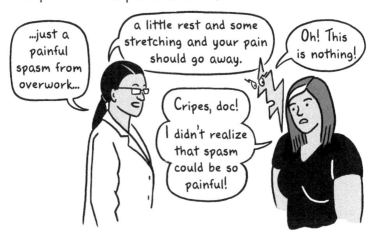

OR THEY CAN **ACCOMPANY** OTHER BACK INJURIES LIKE **MUSCLE STRAIN** OR **DISK HERNIATIONS**.

SYMPTOMS OF **STRAIN** AND SPASM ARE VERY SIMILAR TO TENDON INJURY.

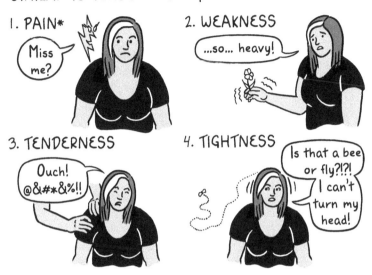

1. PAIN*

2. WEAKNESS

3. TENDERNESS

4. TIGHTNESS

ADDITIONAL SYMPTOMS OF **STRAIN** INCLUDE:

5. SWELLING

6. BRUISING

7. INABILITY TO USE THE TORN MUSCLE

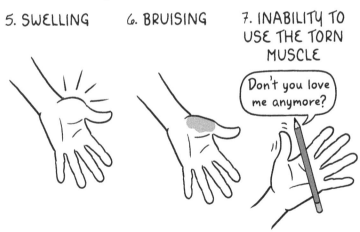

*Can be local or travel to the head (headache) or the buttock (buttache — Ha!). Buttock pain can mimic a nerve entrapment called sciatica.

INTERVERTEBRAL DISCS

INTERVERTEBRAL DISCS **CUSHION** THE **JOINTS** BETWEEN VERTEBRAL BODIES.

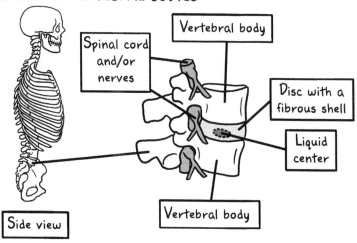

Vertebral body

Spinal cord and/or nerves

Disc with a fibrous shell

Liquid center

Vertebral body

Side view

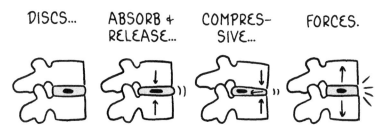

DISCS... ABSORB + RELEASE... COMPRES-SIVE... FORCES.

AGING DISCS COMPRESS, DEHYDRATE, WEAKEN, AND SOMETIMES RUPTURE.

ANATOMY OF *INTERVERTEBRAL DISCS* AND THEIR *INJURIES*

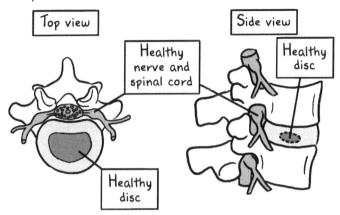

Top view

Side view

Healthy nerve and spinal cord

Healthy disc

Healthy disc

DISC *INJURIES* USUALLY OCCUR IN THE *NECK* AND *LOW BACK.* THE DISC SHELL MAY PARTIALLY OR FULLY *TEAR (RUPTURE).* A DISC MAY *PUSH* OR *BULGE (HERNIATE)* INTO A *NERVE* OR THE *SPINAL CORD.*

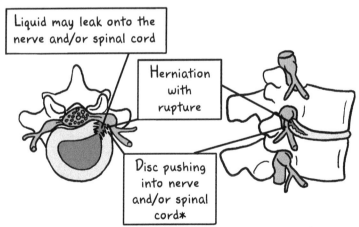

Liquid may leak onto the nerve and/or spinal cord

Herniation with rupture

Disc pushing into nerve and/or spinal cord*

HERNIATIONS ARE OFTEN DUE TO *WEAR AND TEAR* AND *CHANGES* DUE TO *AGING,* POOR POSTURE, OR *POOR MECHANICS* WHEN LIFTING.

*When a disc presses on a nerve, it can cause a nerve entrapment. (See pages 30–33.)

TYPES OF RSIS

NERVE ENTRAPMENTS: PRESSURE FROM BONE, MUSCLE, CARTILAGE, OR SOMETHING ELSE, ON A NERVE. MOST NERVES SEND **SENSORY** SIGNALS **TO** THE BRAIN, AND **MOTOR** SIGNALS THAT CONTRACT MUSCLE **FROM** THE BRAIN.

A diagram of the nervous system

Sensory signals to brain. →
← Motor signals from brain.

Ouch! I think he likes me!

Idiocy stays in brain.

Rrrrr...

COMPRESSION OF A NERVE CAN **INHIBIT SENSORY** AND **MOTOR SIGNALS** FROM TRAVELING ALONG IT. ENTRAPMENTS ARE SOMETIMES CALLED A **"PINCHED NERVE."** THEY CAN PRODUCE **PAIN, NUMBNESS, TINGLING,** AND/OR **WEAKNESS** AS SYMPTOMS.

COMMON NERVE ENTRAPMENTS

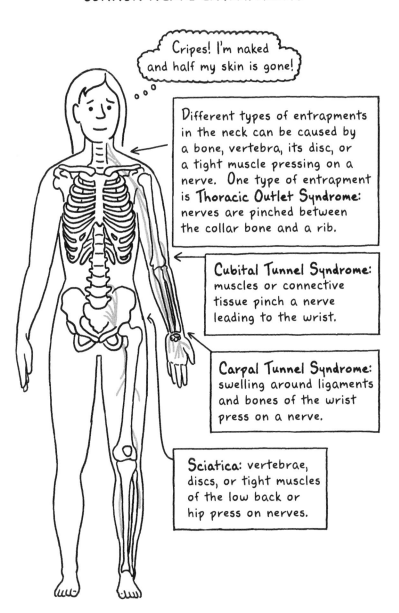

THE CRAZY THING ABOUT NERVE ENTRAPMENT IS THAT A **MUSCLE** OR **BONE** IN THE **NECK** PRESSING ON A NERVE CAN CAUSE SYMPTOMS IN THE **ARM** OR **HAND**. THIS IS WHY IT'S IMPORTANT TO PAY ATTENTION TO **NECK** AND **SHOULDER POSTURE.**

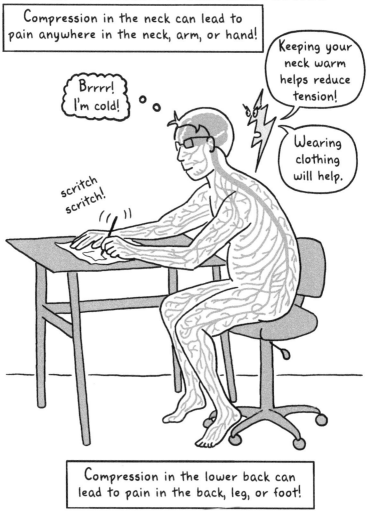

POOR POSTURE CAN LEAD TO NERVE ENTRAPMENT!

SYMPTOMS OF NERVE ENTRAPMENT

PRESSURE FROM A **HERNIATED DISC** ON A **NERVE** CAN CAUSE THE **SAME SYMPTOMS** AS A MUSCLE SPASM PRESSING ON A NERVE.

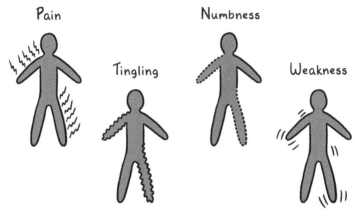

IN THE LOW BACK AND LEG, THESE SYMPTOMS ARE CALLED **SCIATICA**.

IN THE NECK, SHOULDER, ARM, + HAND, THESE SYMPTOMS ARE CALLED **THORACIC OUTLET SYNDROME**, **RADICULOPATHY**, OR **SOMETHING ELSE!**

THE GOOD NEWS IS THAT SELF CARE + PREVENTION FOR DISC AND MUSCLE INJURY ARE ESSENTIALLY **THE SAME!**

Posture, Pain, and Injury

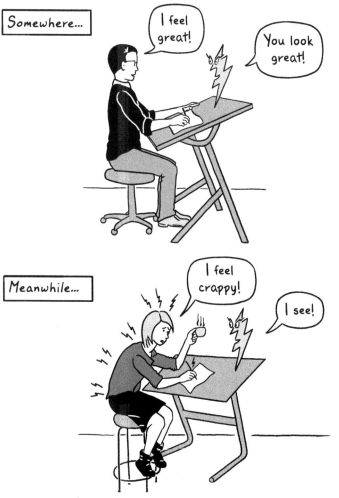

Alignment is critical for pain-free drawing.

DRAWING FOR LONG PERIODS OF TIME TAKES **STAMINA**.

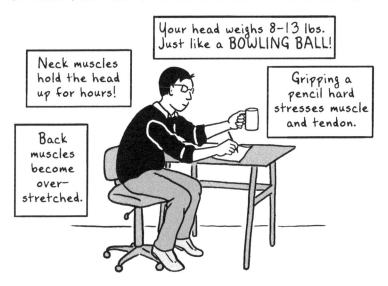

UNFORTUNATELY THE EFFORT REQUIRED TO PRODUCE COMICS CAN LEAD TO **PAINFUL INJURIES**.

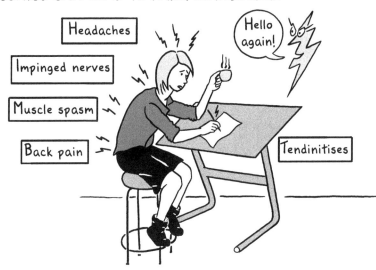

THINK ABOUT IT... MUSCLES HELD IN CHRONICALLY **SHORTENED POSITIONS** WILL **"GROW"** SHORTER, DECREASING IN LENGTH OVER TIME. THEIR **ANTAGONISTIC** MUSCLES (CAUSING THE OPPOSITE ACTION AT A JOINT) WILL **WEAKEN**, GROWING **LONGER**.

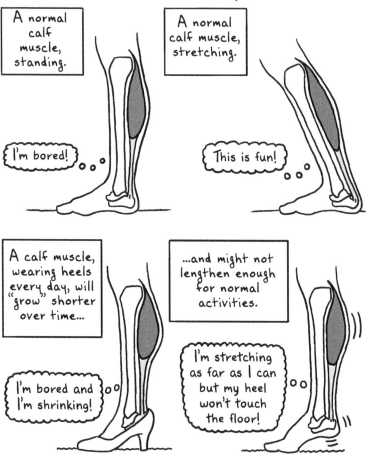

A normal calf muscle, standing.

I'm bored!

A normal calf muscle, stretching.

This is fun!

A calf muscle, wearing heels every day, will "grow" shorter over time...

I'm bored and I'm shrinking!

...and might not lengthen enough for normal activities.

I'm stretching as far as I can but my heel won't touch the floor!

THIS LEADS TO MUSCULAR IMBALANCES AND **INJURY.** NOT ONLY CAN THIS HAPPEN IN YOUR CALF, IT CAN HAPPEN IN THE MUSCLES OF THE **WRIST AND HAND!** FORTUNATELY, IMBALANCES CAN BE **PREVENTED** AND/OR **CORRECTED.**

IF YOU **DRAW** ONLY THREE HOURS A DAY,

TEXT AND USE A HANDHELD DEVICE FOR AN HOUR OR SO,

THEN WORK ON A **LAPTOP** FOR AN HOUR,

AND ROUND OFF YOUR DAY WITH YOUR **STAMP COLLECTION,**

YOU'RE SPENDING AT LEAST **5-6 HOURS PER DAY** IN A HUNCHED-OVER POSITION! OVER TIME, YOUR MUSCLES MAY **"GROW" INTO THIS POSITION.**

GOOD POSTURE* MEANS THAT YOUR BONES AND MUSCLES ARE ORGANIZED TO WORK WITH **OPTIMAL EFFICIENCY.** GOOD POSTURE MAKES YOU **TALLER** AND **SLIMMER!** AND IT MAY HELP YOU **REDUCE PAIN** FROM REPETITIVE STRESS INJURIES.

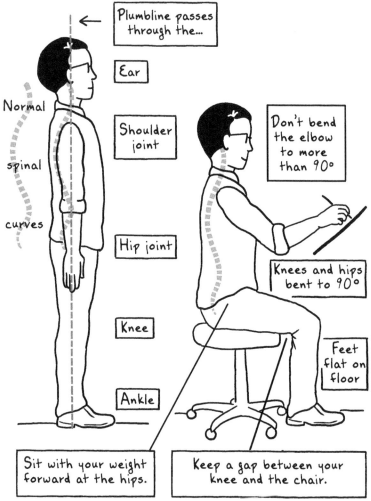

Plumbline passes through the...

Ear

Normal

Shoulder joint

spinal

Hip joint

curves

Knee

Ankle

Don't bend the elbow to more than 90°

Knees and hips bent to 90°

Feet flat on floor

Sit with your weight forward at the hips.

Keep a gap between your knee and the chair.

*It isn't realistic to expect yourself to draw from a position of ideal posture all the time, but it's important to try!

DEVIATING FROM GOOD POSTURE PUTS **STRAIN** ON THE **MUSCLES** AND **JOINTS** OF THE **SHOULDERS**, **BACK**, AND **HIPS**. SITTING **SLOUCHED** FOR **LONG PERIODS** CAN TIGHTEN YOUR **NECK**, **BACK**, AND **THIGH MUSCLES**.

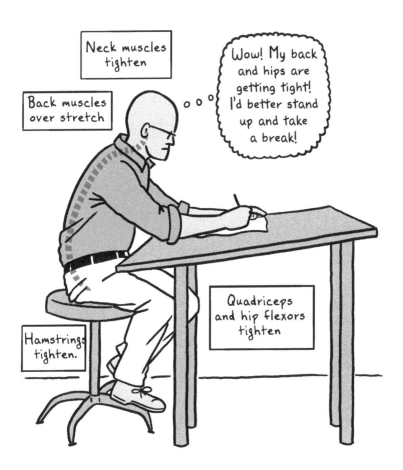

POOR POSTURE IS **STRESSFUL** TO YOUR BODY AND SLOUCHING CAN PUSH YOUR GUT OUT AND MAKE YOU LOOK OUT OF SHAPE.

WHEN YOU STAND UP AFTER **SITTING FOR LONG PERIODS,** TIGHT HIP AND THIGH MUSCLES CAN **MAKE POSTURE WORSE!** HERE ARE **TWO POSSIBLE POSTURES** THAT CAN RESULT FROM SITTING FOR LONG PERIODS OF TIME **WITHOUT A BREAK.**

1. TIGHT HAMSTRINGS TUCK THE **PELVIS UNDER** AND **FLEX** (BEND) THE **BACK** FORWARD.

2. TIGHT HIP FLEXORS TIP THE **PELVIS FORWARD** AND **ARCH** THE **BACK.**

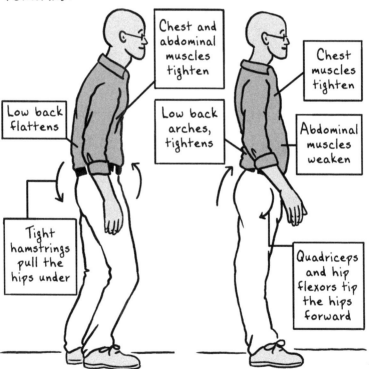

Chest and abdominal muscles tighten

Low back flattens

Tight hamstrings pull the hips under

Low back arches, tightens

Chest muscles tighten

Abdominal muscles weaken

Quadriceps and hip flexors tip the hips forward

EITHER WAY, YOUR **NECK, SHOULDERS,** AND **BACK** CAN BECOME **PAINFUL.**

IF YOU DON'T **COUNTERRACT** THIS POSTURE WITH SOME **EXERCISE**, IT WILL BECOME "NORMAL" TO YOU.

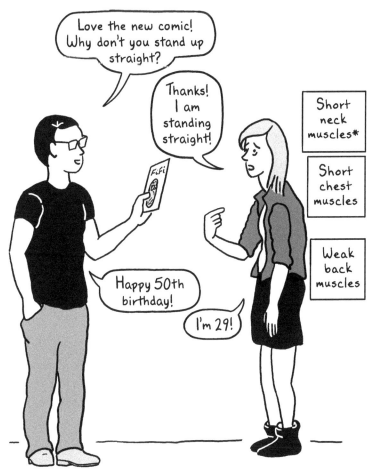

*Short muscles have "grown" too short to lengthen into normal posture!

PHYSICAL ACTIVITY CAN HELP **REDUCE** THE CHANCE OF **INJURY** VIA INCREASED **FLEXIBILITY**, **STABILITY**, AND **ENDURANCE** TO MAINTAIN POSTURE AND REDUCE TENSION IN TIGHT MUSCLES.

Get a Grip!

How you hold your stylus can improve your drawing and your comfort!

DRAWING TECHNIQUE BASICS

THERE ARE MANY WAYS TO **GRASP** A DRAWING TOOL. CERTAIN HAND POSITIONS ARE BETTER FOR **DIFFERENT** TYPES OF LINES.

TWO BASIC GRASPS:

TRIPOD

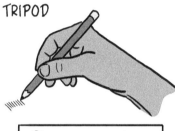

VIOLIN BOW

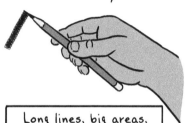

Get a grip!

| Short, precise lines and detailing, uses hand muscles. | Long lines, big areas, uses shoulder muscles. |

HOW YOU HOLD A TOOL AND USE THE GRASP **CAN VARY** WITH THE **ANGLE** OF YOUR DRAWING **SURFACE** AND THE **SIZE** OF YOUR DRAWING.

THE VIOLIN GRIP MAY NOT WORK WITH A **DIGITAL STYLUS PEN** DUE TO ITS TIP DESIGN. EVEN SO, YOU CAN USE **DIFFERENT PARTS** OF YOUR ARM AND DIFFERENT **SURFACE ANGLES** FOR MARK MAKING.

GUIDELINES FOR HEALTHY DRAWING TECHNIQUE

1. KEEP YOUR HAND **RELAXED**. SIGNS THAT YOUR GRIP IS PROBABLY **TOO TIGHT**:

REDDENING OR **BLANCHING** OF YOUR FINGERS.

HYPEREXTENDING YOUR FINGER JOINTS.

"PULLING" THE STYLUS TOWARDS YOUR PALM WHILE DRAWING.

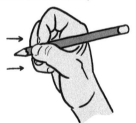

HUGE **CALLUSES** ON YOUR DRAWING FINGERS.

Draws 15 hours/week with a tight grip.

Draws 15 hours/week with a relaxed grip.

Big calluses prove I'm a great artist!

Um... well...

2. ASSIGN THE MOVEMENTS CREATING YOUR LINES TO *DIFFERENT JOINTS*. THIS TAKES STRAIN OFF OF ANY *SINGLE JOINT*.

TINY LINES ARE CON-
TROLLED BY **FINGERS**.

SHORT LINES ARE
CONTROLLED BY THE
WRIST.

Scritch!
Scritch!

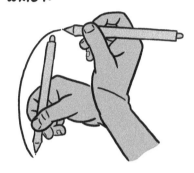

MEDIUM LINES ARE
ANCHORED AT THE
ELBOW AND MOVED BY
THE MUSCLES OF THE
SHOULDER.

LONG LINES ARE
CONTROLLED AT THE
SHOULDER. THE
ELBOW MAY HELP OUT.

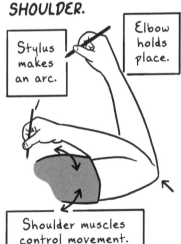

Stylus makes an arc.

Elbow holds place.

Shoulder muscles control movement.

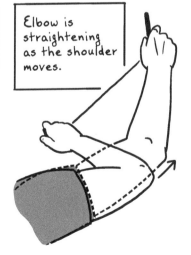

Elbow is straightening as the shoulder moves.

Think Like a Cartoonist-Athlete

Self care is important!

CARTOONISTS FEEL MUSCLE **FATIGUE, PAIN,** AND **SPASM,** JUST LIKE ANY OTHER ATHLETE.

ATHLETES TRAIN TO **ENHANCE** THEIR **PERFORMANCE** AND AVOID INJURY. **CARTOONISTS SHOULD TRAIN** TOO!

SKILLED ATHLETES UNDERSTAND THAT THEY **CAN'T EXCLUSIVELY** PERFORM THEIR SPORT OR ACTIVITY TO STAY ON TOP OF THEIR GAME. THEY NEED TO COMBINE **SPECIFIC** AND **GENERAL** ACTIVITIES TO TRAIN. IT'S THE SAME FOR CARTOONISTS.

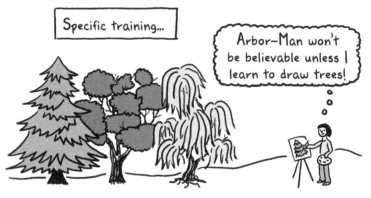

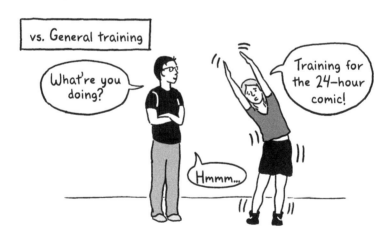

THROUGH EXERCISE/TRAINING, CARTOONISTS CAN **IMPROVE POSTURE, STRENGTH,** AND **FLEXIBILITY** AND **PREVENT** SOME MUSCULOSKELETAL **INJURIES** BROUGHT ON BY MARATHON DRAWING SESSIONS.

MANY FACTORS CONTRIBUTE TO PAIN SYNDROMES AND INJURY, EVEN IF WE WORK TO PREVENT THEM.

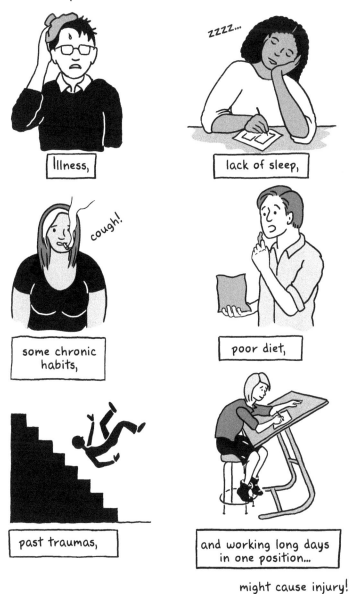

Illness,

lack of sleep,

some chronic habits,

poor diet,

past traumas,

and working long days in one position...

might cause injury!

Live Like a Cartoonist-Athlete

Modify drawing and other activities
to reduce chance of injury 24/7.

TIPS FOR **HEALTHY DRAWING**

1. FOR NECK AND BACK PAIN, **IMPROVING POSTURE** MAY **REDUCE STRESS** ON THE AREA AND THEREFORE **"RESTS"*** YOUR NECK AND BACK.

An inclined drawing surface reduces strain.

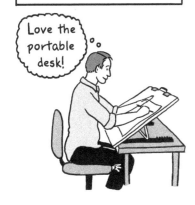

If you can, stand for some activities and sit for others.

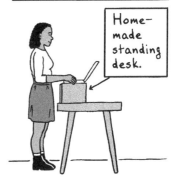

Experiment with desk, chair, or computer height.

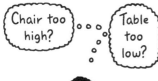

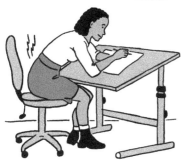

Get off the floor! Sit up straight.*

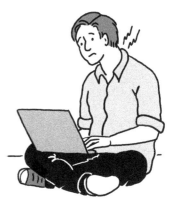

*See "Rest" on pages 113–5.

2. WHEN DRAWING OR WORKING AT A DESK TAKE REGULAR BREAKS*. GET OUT OF YOUR CHAIR, PERFORM **GENTLE** MOVEMENTS TO **REDUCE** TENSION AND **IMPROVE** POSTURE.

FOR THE **BACK,**

THE **NECK** AND **SHOULDERS,**

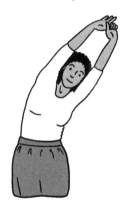

THE **WRISTS** AND **HANDS**, AND YOUR **WHOLE BODY.**

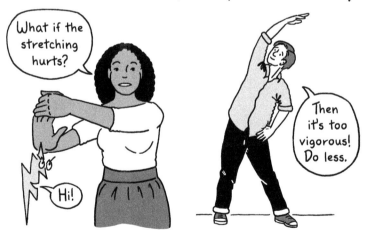

*How long should a break last? It can be just a few minutes. How often should you take a break? You will have to figure out what you need. It can be every 30–90 minutes.

3. GET ENOUGH **REST**.

4. **EAT WELL.**

5. PERFORMANCE IS BEST WITH GOOD EQUIPMENT: **PAY ATTENTION** TO YOUR **DESK, CHAIR,** AND **LIGHTING.**

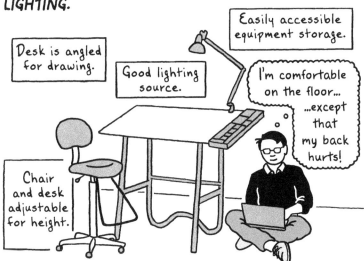

6. *OVER-STRETCHING* BACK MUSCLES OR USING *POOR POSTURE* WHILE LIFTING HEAVY OBJECTS CAN CAUSE MUSCLE *SPASM, STRAIN,* OR *DISK INJURY*.

Bad positioning for lifting: back bent and knees too straight.

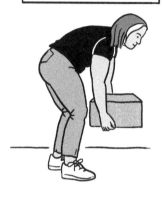

Good positioning for lifting: Knees bent, back upright.

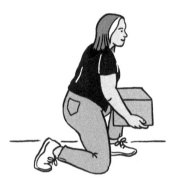

Poor posture for carrying: holding the item to far away with the hips bent.

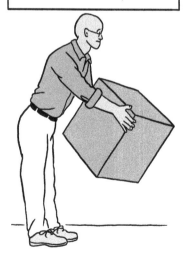

Good posture for carrying: holding the item close with the back straight.

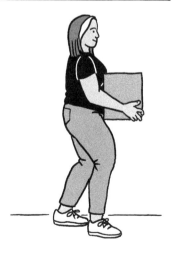

6A. MORE TIPS FOR **SAFE LIFTING.**

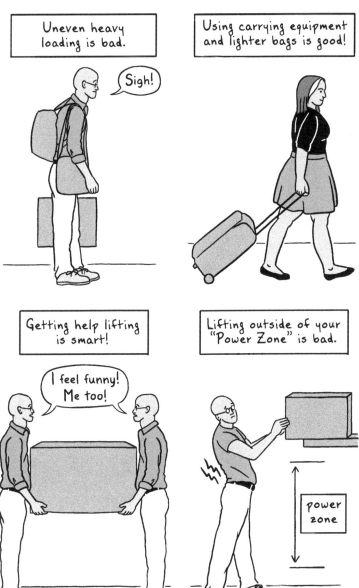

Train Like a Cartoonist-Athlete

Read these guidelines before starting your exercise routines.

TIPS FOR TRAINING

1. IF YOU ARE **INJURED**, ARE IN **PAIN**, OR **DO NOT** CURRENTLY **EXERCISE**, CONSULT A QUALIFIED HEALTHCARE PRACTITIONER BEFORE STARTING YOUR CARTOONIST-ATHLETE **TRAINING**.

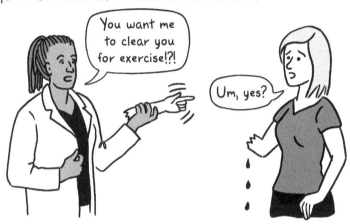

2. ALL EXERCISES SHOULD BE **PAIN FREE!**

3. START WITH **FEWER REPETITIONS**. INCREASE "REPS" **SLOWLY** OVER TIME.

4. PREPARE TO DRAW WITH A 5-15 MINUTE **WARM UP.** A WARM UP IS MADE OF **EASY, STRESSLESS, PAIN-FREE** MOVEMENTS THAT **READY YOUR BODY** FOR INTENSE DRAWING.

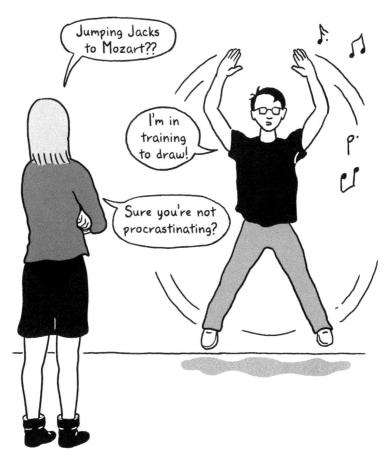

THE **IDEAL** WARM UP INCLUDES **FULL BODY** ACTIVITY LIKE MARCHING IN PLACE, BRISK WALKING, JUMPING JACKS, EASY JOGGING, OR DANCING. GET YOUR HEART **PUMPING** WITH RHYTHMIC, EASY, **LARGE MOVES** THAT "WAKE UP" MUSCLES AND WARM TISSUES.

5. DO SOMETHING *FUN* AND *PHYSICAL* AT LEAST *3 TIMES PER WEEK.*

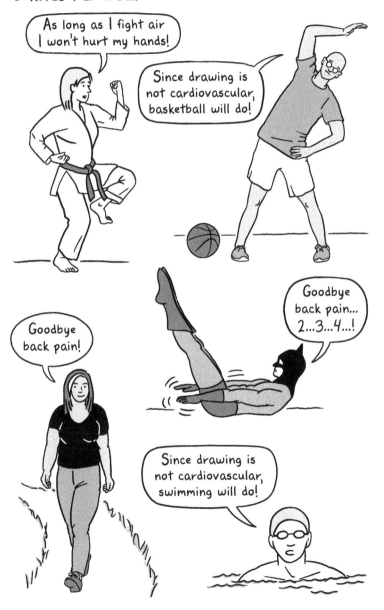

6. PERFORM STRENGTHENING AND STRETCHING EXERCISES **REGULARLY,** EVEN ON DAYS WHEN YOU ARE NOT DRAWING.

7. GENERALLY, IT IS BETTER TO **STRENGTHEN** AN AREA **FIRST** AND THEN **STRETCH** IT **SECOND.**

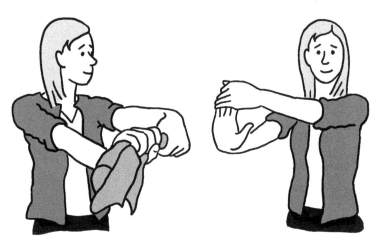

Hand and wrist exercises start on page 64.

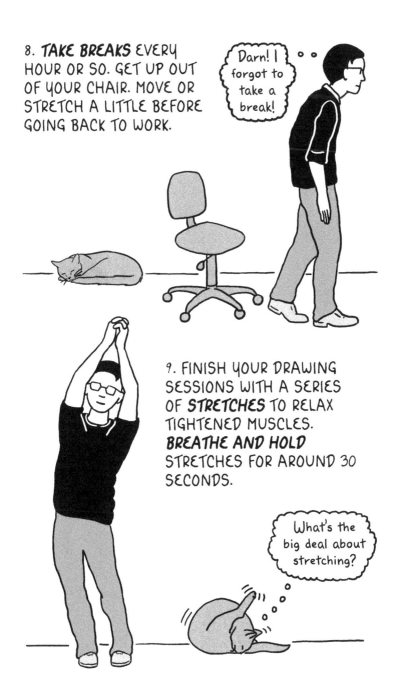

8. **TAKE BREAKS** EVERY HOUR OR SO. GET UP OUT OF YOUR CHAIR. MOVE OR STRETCH A LITTLE BEFORE GOING BACK TO WORK.

Darn! I forgot to take a break!

9. FINISH YOUR DRAWING SESSIONS WITH A SERIES OF **STRETCHES** TO RELAX TIGHTENED MUSCLES. **BREATHE AND HOLD** STRETCHES FOR AROUND 30 SECONDS.

What's the big deal about stretching?

10. **AFTER DRAWING,** STRETCHES CAN TARGET WHATEVER YOU FEEL IS TIGHTENING UP. **BEWARE!!!** PEOPLE OFTEN FEEL THEIR **UPPER BACK** AND **SHOULDER** MUSCLES TIGHTEN AS THEY DRAW. THE MUSCLES ARE **OVER-STRETCHING** AND FEEL **TIGHT,** BUT TO STRETCH THEM MORE IS **COUNTER-PRODUCTIVE!** AT THE END OF THE DAY, INCLUDE **CHEST STRETCHES** TO **COUNTERACT** YOUR DRAWING POSTURE.

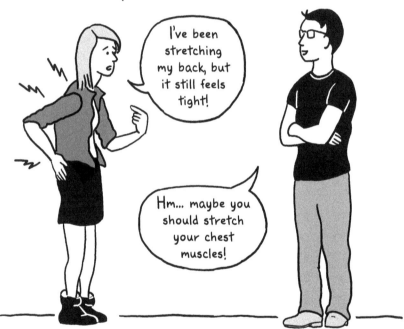

I've been stretching my back, but it still feels tight!

Hm... maybe you should stretch your chest muscles!

11. **STRENGTHENERS** SHOULD **NOT** BE DONE TO THE POINT OF EXHAUSTION **BEFORE** YOU START DRAWING. SLOWLY ADD REPS OVER TIME. YOU CAN EVENTUALLY ADD ANOTHER SET OF REPETITIONS TO KEEP BUILDING STRENGTH.
IF YOU DECIDE TO GIVE YOURSELF A **HARD** WORK OUT, **DON'T** DO IT **BEFORE** AN EXTENDED DRAWING SESSION. GIVE YOUR BODY A LITTLE TIME TO RECOVER.

Exercises for the Hand and Wrist

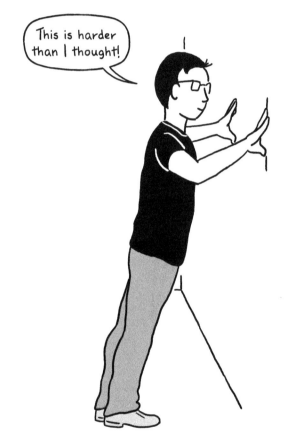

These are easy to combine with exercises for the neck and shoulders!

EASY MOVEMENTS - SHAKING HANDS

1. HOLDING YOUR HANDS **LOW** BY YOUR HIPS, SHAKE YOUR HANDS FROM **SIDE TO SIDE**. →

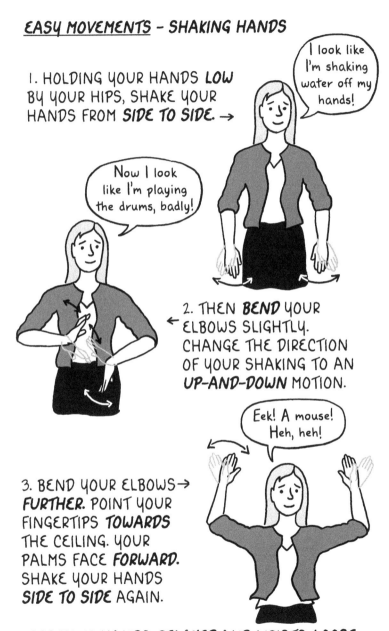

I look like I'm shaking water off my hands!

Now I look like I'm playing the drums, badly!

2. THEN **BEND** YOUR ELBOWS SLIGHTLY. CHANGE THE DIRECTION OF YOUR SHAKING TO AN **UP-AND-DOWN** MOTION.

Eek! A mouse! Heh, heh!

3. BEND YOUR ELBOWS→ **FURTHER**. POINT YOUR FINGERTIPS **TOWARDS** THE CEILING. YOUR PALMS FACE **FORWARD**. SHAKE YOUR HANDS **SIDE TO SIDE** AGAIN.

KEEP YOUR HANDS **RELAXED** AND WRISTS **LOOSE**.

EASY MOVEMENTS – SPIDER ON A MIRROR

1. **ALIGN** AND TOUCH TOGETHER THE **FINGERTIPS** OF BOTH YOUR **HANDS**.

2. GENTLY **PUSH** YOUR FINGERTIPS AGAINST ONE ANOTHER. AS YOU PUSH, LET YOUR FINGERS **FLAIR** OUT AS FAR AS THEY WILL GO.

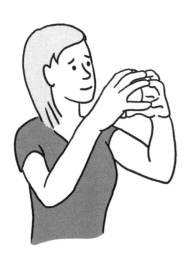

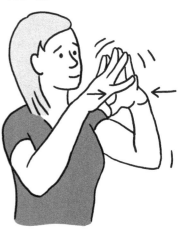

3. MAINTAINING **PRESSURE,** DRAW YOUR FINGERTIPS BACK TOGETHER.

REMEMBER **THE SPIDER-DOING-PUSH-UPS-ON-A-MIRROR JOKE?** THAT'S THE ACTION YOU WANT TO DO.

I hate push-ups!

REPEAT 5–10 TIMES.

STRENGTHENERS - FINGERTIP PUSH-UPS ON A WALL

STAND A COUPLE FEET AWAY FROM A WALL, ELBOWS **STRAIGHT** AND FINGERTIPS RESTING AT **SHOULDER** HEIGHT. KEEP YOUR HANDS IN A **DOMED** SHAPE AND LEAN **INTO** THE WALL. YOUR ELBOWS WILL BEND **AWAY** FROM YOUR BODY. THEN STRAIGHTEN YOUR ELBOWS, PUSHING **OUT**.

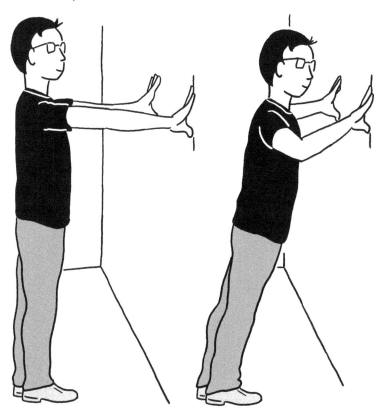

IF YOUR FINGERS BUCKLE AND **LOSE THEIR ARCH,** YOU'RE LEANING **TOO HARD!**

REPEAT 4-8 TIMES.

STRENGTHENERS – SQUEEZE A TOWEL

WAD UP A TOWEL
OR WASHCLOTH.
SQUEEZE IT FIRMLY
FOR 2-3 SECONDS.
USE YOUR FINGERS
AND YOUR THUMB.
RELAX THEN REPEAT
5-8 TIMES WITH **EACH
HAND.**

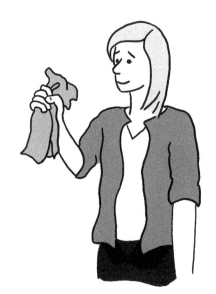

STRENGTHENERS – WRING A TOWEL

1. GRAB THE TOWEL
IN **BOTH** HANDS,
HOLDING IT **AWAY**
FROM YOUR BODY,
ELBOW **STRAIGHT**
AND THUMBS
TOUCHING.

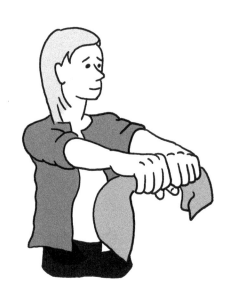

STRENGTHENERS – WRING A TOWEL (continued)

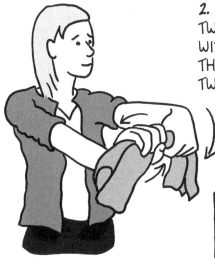

2. SQUEEZE THE TOWEL, TWISTING **BACK** ON IT WITH ONE HAND WHILE THE **OTHER** HAND TWISTS IT **FORWARD**.

Keep those elbows straight to work your wrists harder!

3. REVERSE THE ACTION, TWISTING **BACKWARDS** AND **FORWARDS** WITH **OPPOSITE** HANDS.

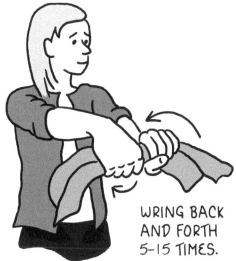

WRING BACK AND FORTH 5-15 TIMES.

STRENGTHENERS – FINGER SPREAD

THIS EXERCISE **STRENGTHENS** THE MUSCLES THAT **LET GO** OF YOUR PENCIL OR STYLUS. THEY ALSO **EXTEND THE WRIST** (PULL IT BACK). THESE MUSCLES TEND TO BE **WEAK** IN DRAWERS.

START WITH A **RUBBER BAND** AROUND THE **ENDS** OF ALL FIVE FINGERS, IN A CLOSED POSITION. THE **THICKER** AND/OR **SMALLER** THE RUBBER BAND, THE **GREATER THE RESISTANCE.**

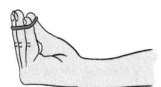

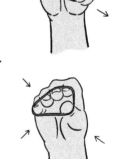

1. OPEN YOUR FINGERS, HOLDING FOR 3 SECONDS.

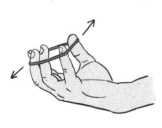

2. SLOWLY CLOSE YOUR FINGERS.

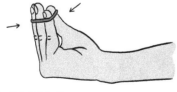

3. REPEAT.

DO THIS EXERCISE BETWEEN 3–8 TIMES.

STRETCHES – FLEXOR STRETCH

(THE **"FLEXORS"** FLEX THE WRIST AND HAND. THEY CURL THE WRIST AND FINGERS INTO A FIST.)

1. HOLD YOUR **RIGHT** ARM AND HAND IN FRONT OF YOU, PALM **RAISED** AND → FACING **FORWARD**.

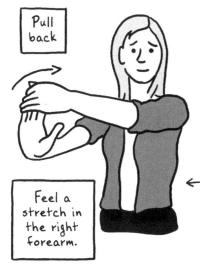

Pull back

Feel a stretch in the right forearm.

2. USING YOUR **LEFT** HAND, **PULL** YOUR (R) FINGERS 2-5 **TOWARDS** YOU. HOLD FOR ← THREE BREATHS.

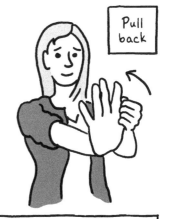

Pull back

3. RELEASE YOUR FINGERS AND PULL YOUR **THUMB TOWARDS** YOU. HOLD FOR THREE BREATHS. RELEASE. REPEAT ON THE LEFT SIDE **EVEN IF YOU ARE RIGHT DOMINANT.** →

Feel a stretch in the base of the right thumb or forearm.

REPEAT TWICE EACH SIDE.

STRETCHES – EXTENSOR STRETCH

(THE **"EXTENSORS"** STRAIGHTEN THE FINGERS AND PULL THE WRIST BACK.)

1. HOLD EITHER ARM IN **FRONT** OF YOU, ELBOW **STRAIGHT.** DROP YOUR FINGERS TOWARDS THE **GROUND.** GENTLY PULL FINGERS 2-5 **TOWARDS** YOU. BREATHE. RELEASE.

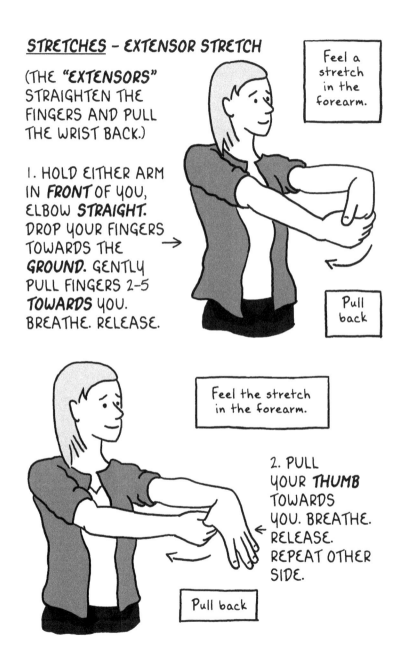

Feel a stretch in the forearm.

Pull back

Feel the stretch in the forearm.

2. PULL YOUR **THUMB** TOWARDS YOU. BREATHE. RELEASE. REPEAT OTHER SIDE.

Pull back

REPEAT 2 TIMES EACH SIDE.

Exercises for the Neck, Chest, and Shoulders

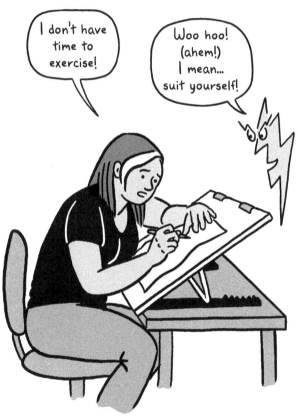

Good for good posture!

EASY MOVEMENTS - SHOULDER ROLLS
BREATHE DEEPLY THROUGHOUT THIS EXERCISE.

KEEPING YOUR SPINE UPRIGHT, DESCRIBE A **CIRCLE** WITH BOTH **SHOULDERS**.

 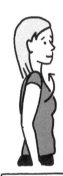 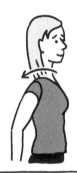 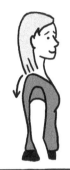

To the front,	up towards your ears,	back towards your spine,	down towards your hips.

CIRCLE **"FORWARD"** 3- 5 TIMES. THEN REVERSE DIRECTION, CIRCLING TO THE **"BACK"** 3-5 TIMES. MOVE YOUR SHOULDERS **AS FAR AS THEY WILL GO** IN ALL DIRECTIONS.

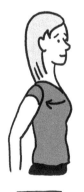 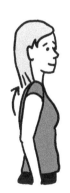 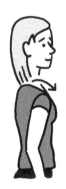 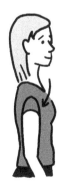

Back,	up,	forward,	down.

EASY MOVEMENTS – HELICOPTER

LIFT YOUR ARMS TO THE SIDE. KEEP YOUR UPPER ARM AND ELBOW **IN PLACE** AS YOU CIRCLE YOUR HANDS **CLOCKWISE** AND **COUNTERCLOCKWISE.** CIRCLE **8 TIMES** IN EACH DIRECTION.

Keep your shoulders below 90°

If I really had this many hands I'd never miss a deadline!

THE PENDULUM CIRCLE

BEND OVER AT THE HIPS (AROUND 90°). LET ONE ARM **HANG DOWN** TOWARDS THE FLOOR. **RELAX** YOUR SHOULDER AND ARM & **GENTLY** SHIFT YOUR BODY TO THE SIDE/BACK/SIDE/FRONT, TO INITIATE **MOMENTUM** & SWING YOUR ARM IN **SMALL CIRCLES.** TRY TO KEEP THE SHOULDER RELAXED. CIRCLE IN BOTH DIRECTIONS.

IF YOUR BACK IS **UNCOMFORTABLE** BEND OVER **LESS;** USE YOUR NON-SWINGING HAND ON YOUR THIGH, OR PLACE THE N-S HAND ON A TABLE FOR **SUPPORT.**

Hey! A dime!

<u>STRENGTHENERS</u> – SHOULDER PULLS

INHALE. PULL YOUR SHOULDER BLADES ***BACK*** TOWARDS YOUR SPINE AS FAR AS THEY WILL GO. THIS IS CALLED ***SCAPULAR RETRACTION.*** COUNT TO 4 SLOWLY. EXHALE AND RELAX YOUR SHOULDERS.

1. START WITH UPRIGHT, NEUTRAL POSTURE.

2. SQUEEZE YOUR SHOULDERS TOGETHER.

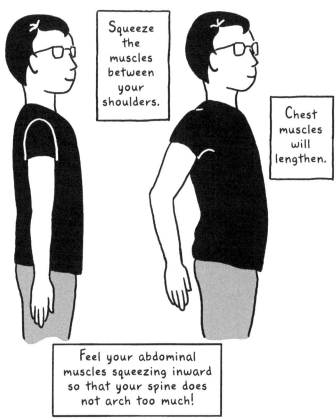

Squeeze the muscles between your shoulders.

Chest muscles will lengthen.

Feel your abdominal muscles squeezing inward so that your spine does not arch too much!

3. END BACK IN NEUTRAL POSTURE.

REPEAT 4–8 TIMES.

STRENGTHENERS - SHOULDER DIPS

ANCHOR YOUR HANDS TO THE EDGE OF A **STABLE** CHAIR. SCOOT YOUR BUTT OFF THE CHAIR'S EDGE. **INHALE** AND LET YOUR BODY **SINK** TOWARDS THE FLOOR AS YOUR SHOULDERS **RISE. EXHALE**, AND PUSH DOWN ON THE CHAIR. YOUR BODY **LIFTS** AS SHOULDERS **DEPRESS**. KEEP YOUR ELBOWS **STRAIGHT** THROUGH THE ENTIRE EXERCISE.

1. BUTT OFF CHAIR.

2. LOWER YOUR BODY. SHOULDERS UP, BUTT DOWN!

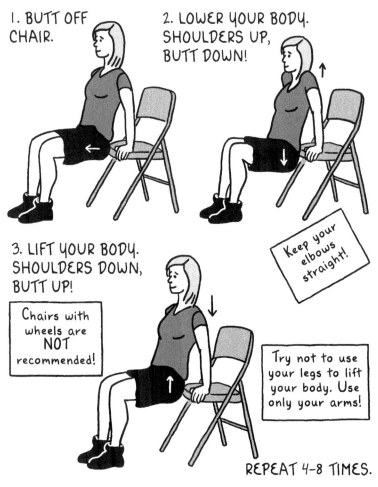

Keep your elbows straight!

3. LIFT YOUR BODY. SHOULDERS DOWN, BUTT UP!

Chairs with wheels are NOT recommended!

Try not to use your legs to lift your body. Use only your arms!

REPEAT 4-8 TIMES.

STRENGTHENERS - SIDE PLANK

THE **SIDE PLANK** POSITION WILL TARGET THE
MUSCLES OF THE **SHOULDERS** AND **WAIST.** USING
THE **FOREARM** INSTEAD OF THE **HAND** FOR SUPPORT
WILL KEEP YOUR WRIST FROM OVERLOAD.

Can't hold the
pose in the lower
picture? Start
by propping up
on your knees
instead of your
feet. This will
help you build up
trunk strength.

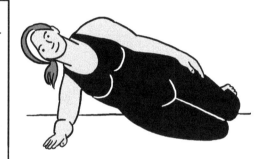

For additional effort take your
arm up towards the ceiling.

Keep a straight line
from head to heels.

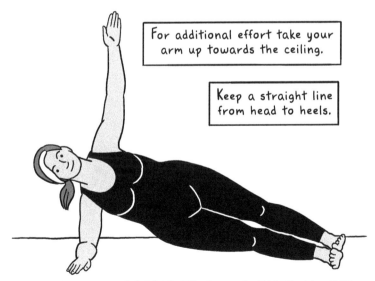

HOLD FROM *1-15 SECONDS.* DO 1-3 TIMES ON THE
RIGHT AND LEFT SIDES.

STRENGTHENERS - EXERCISES FOR THE ROTATOR CUFF

PRESSING IN
BEND YOUR ELBOW TO
90° AND PLACE THE
PALM OF YOUR HAND
ON THE SILL OF A
DOOR JAMB. INHALE.
EXHALE AND **GENTLY**
BUT FIRMLY PRESS
YOUR PALM INTO THE
SILL FOR THE COUNT
OF 4. INHALE AND
RELAX.

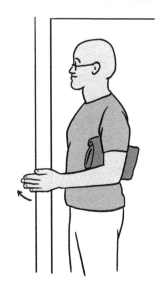

PRESSING IN
SHIFT YOUR POSITION
SO THAT THE **BACK**
OF YOUR HAND IS
TOUCHING THE SILL.
INHALE. EXHALE AND
GENTLY BUT FIRMLY
PRESS THE BACK OF
YOUR HAND INTO THE
SILL FOR THE COUNT
OF 4. INHALE AND
RELAX.

Hold a rolled up towel
between your elbow and
your ribs. This helps
support the shoulder.

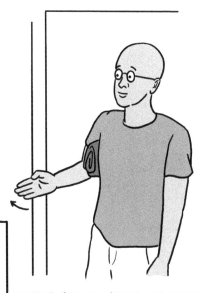

REPEAT 4-10 TIMES EACH SIDE.

STRETCHES - NECK STRETCH #1

1. START IN AN UPRIGHT POSITION.

2. LET YOUR HEAD FALL FORWARD. GENTLY STRETCH THE BACK OF YOUR NECK. BREATHE.

Keep your spine straight!

3. WHILE YOUR HEAD IS FORWARD, SLOWLY **TURN** YOUR HEAD TO LOOK AT YOUR **RIGHT** THIGH. GENTLY **MOVE** YOUR HEAD OVER TO THE **RIGHT**. BREATHE.

4. SLOWLY **TURN** YOUR HEAD TO LOOK AT YOUR **LEFT** THIGH, AND **MOVE** IT OVER TO THE **LEFT**. BREATHE. BRING YOUR HEAD BACK TO CENTER.

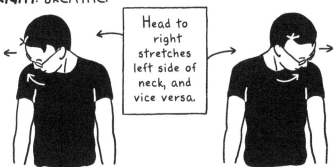

Head to right stretches left side of neck, and vice versa.

LIFT YOUR HEAD. **ROLL** YOUR **SHOULDERS** ONCE OR TWICE. REPEAT 1-3 TIMES.

<u>STRETCHES</u> – NECK STRETCH #2

STARTING FROM AN UPRIGHT POSTURE, LET YOUR HEAD GENTLY FALL TO THE **RIGHT. BREATHE** AWHILE. LIFT YOUR HEAD.

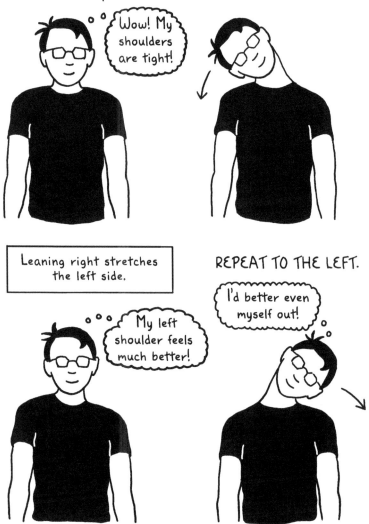

PERFORM THIS STRETCH 1–3 TIMES.

STRETCHES – CHEST STRETCH #1

SITTING OR STANDING UPRIGHT, **CLASP** YOUR HANDS **BEHIND** YOU.

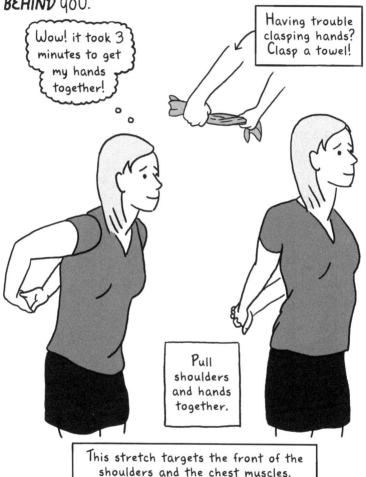

Wow! it took 3 minutes to get my hands together!

Having trouble clasping hands? Clasp a towel!

Pull shoulders and hands together.

This stretch targets the front of the shoulders and the chest muscles.

HOLDING YOUR **CLASPED** HANDS AT YOUR HIPS, TRY TO **STRAIGHTEN** YOUR **ELBOWS** AND **ARCH** YOUR BACK AND CHEST. INHALE AND EXHALE DEEPLY TWO OR THREE TIMES. RELAX AND RELEASE YOUR GRIP.

REPEAT 2–3 TIMES.

STRETCHES - CHEST STRETCH #2

THIS **DOOR STRETCH** IS ANOTHER WAY TO **OPEN** THE **CHEST** AND **SHOULDERS**.

STANDING IN A DOORWAY, **HOLD ON** TO THE DOOR JAMB WITH YOUR HAND. TRY TO MAKE YOUR ARM **HORIZONTAL** TO THE FLOOR. KEEPING YOUR **ELBOW STRAIGHT,** TURN YOUR BODY **AWAY** FROM YOUR ARM UNTIL YOU FEEL A **GENTLE STRETCH** IN YOUR **CHEST.** **HOLD** AND **BREATHE** DEEPLY AND SLOWLY FOR ABOUT **30 SECONDS.**

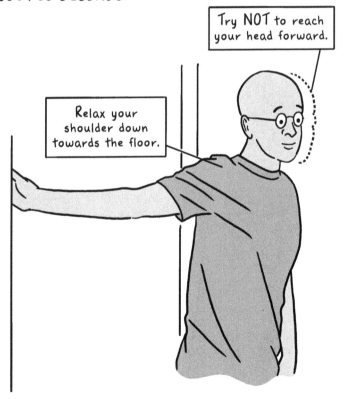

STRETCH BOTH SIDES 1-2 TIMES.

Exercises for the Back

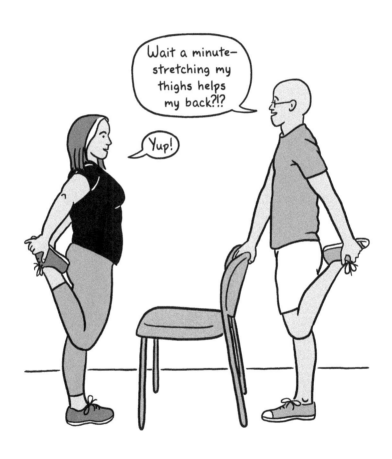

Also good for good posture!

EASY MOVEMENTS FOR THE BACK – BREATHING

THIS SIMPLE BREATHING EXERCISE CAN HELP **RELAX MUSCLE SPASM**, **FOCUS** YOUR MIND, **ACTIVATE** YOUR **CORE**, AND READY YOUR TRUNK FOR EXERCISE.

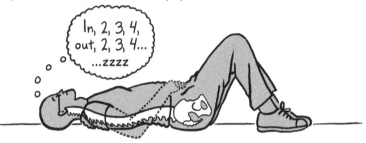

1. LAY ON YOUR BACK, KNEES BENT. BREATHE IN AND OUT SLOWLY (4 COUNT). YOUR LOWER BACK CAN BE OFF THE FLOOR.

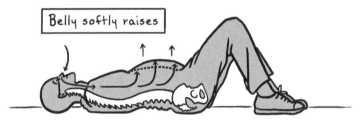

2. AS YOU INHALE, IMAGINE YOU CAN FILL YOUR BELLY WITH AIR.

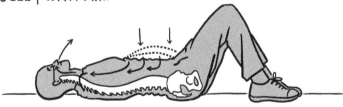

3. AS YOU EXHALE, SQUEEZE YOUR BELLY TOWARDS YOUR SPINE. TAKE A FEW BREATHS BY "FILLING YOUR BELLY WITH AIR" AND SQUEEZING IT OUT.

REPEAT 2-4 TIMES THEN TURN THE PAGE...

EASY MOVEMENTS FOR THE BACK – BREATHING
(cont'd)

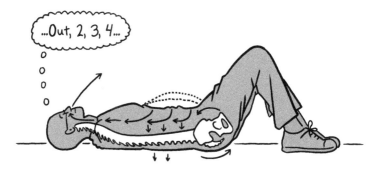

4. NOW FLATTEN YOUR LOW BACK TO THE FLOOR WITH EACH EXHALATION. TRY TO DO THIS BY SQUEEZING YOUR LOWER ABDOMINAL MUSCLES AND "TUCKING YOUR PELVIS UNDER."

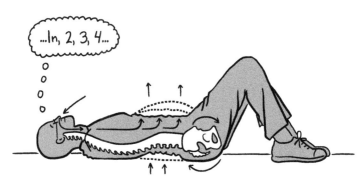

5. AS YOU INHALE "INTO" YOUR ABDOMEN, GENTLY ARCH YOUR LOWER BACK UNTIL YOU RETURN TO YOUR NEUTRAL STARTING POSITION.

REPEAT STEPS FOUR THROUGH FIVE 2–4 TIMES.

EASY MOVEMENTS - PELVIC ROCKING

1. SIT ON THE FORWARD EDGE OF YOUR CHAIR, WITH YOUR **BEST POSTURE**, ARMS AT YOUR SIDES → OR IN YOUR LAP.

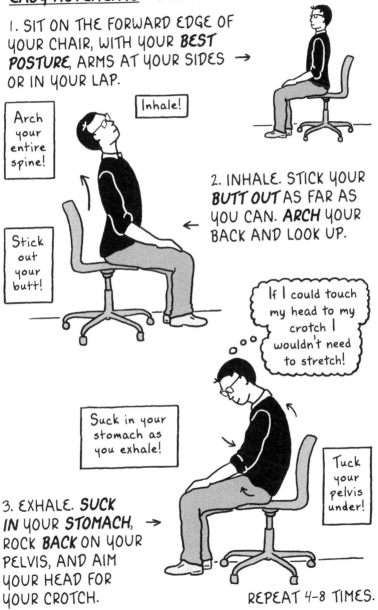

Inhale!

Arch your entire spine!

Stick out your butt!

2. INHALE. STICK YOUR **BUTT OUT** AS FAR AS YOU CAN. **ARCH** YOUR BACK AND LOOK UP.

If I could touch my head to my crotch I wouldn't need to stretch!

Suck in your stomach as you exhale!

Tuck your pelvis under!

3. EXHALE. **SUCK IN** YOUR **STOMACH**, → ROCK **BACK** ON YOUR PELVIS, AND AIM YOUR HEAD FOR YOUR CROTCH.

REPEAT 4-8 TIMES.

CORE STRENGTHENING - SLOW CRUNCHES

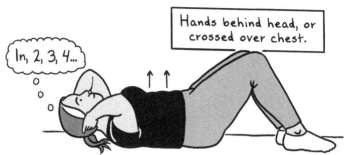

1. ON YOUR BACK, KNEES BENT, FEET ON THE FLOOR, SLOWLY BREATHE IN FOR 4 COUNTS.

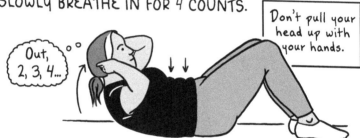

2. EXHALE FOR 4 COUNTS WHILE TUCKING YOUR CHIN AND LIFTING YOUR HEAD AND SHOULDERS. SQUEEZE YOUR ABDOMEN TOWARDS YOUR SPINE.

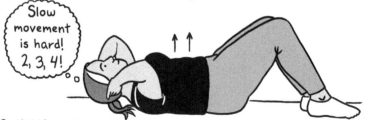

3. INHALE AND LOWER DOWN FOR FOUR COUNTS. RETURN TO STEP 2 AND REPEAT. MOVE **SLOWLY** THROUGHOUT THE EXERCISE.

IF CRUNCHES ARE PAINFUL, TRY A PLANK INSTEAD. DEPENDING ON YOUR **STRENGTH**, YOU CAN **START** WITH **3-5** REPS AND **BUILD TO** 10 REPS OVER TIME.

CORE STRENGTHENING - PLANK VARIATIONS

IN **PLANK POSE,** THE IDEA IS TO KEEP YOUR **TORSO** AND **HIPS** IN A **STRAIGHT LINE** AND HOLD YOURSELF OFF THE GROUND FOR AS LONG AS YOU CAN.

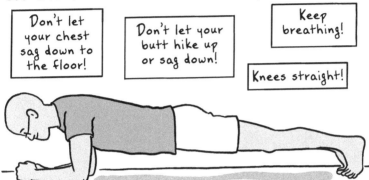

BENDING YOUR KNEES OR USING A COUNTER OR TABLE IS AN OPTION IF YOU ARE NOT STRONG ENOUGH FOR THE FULL PLANK.

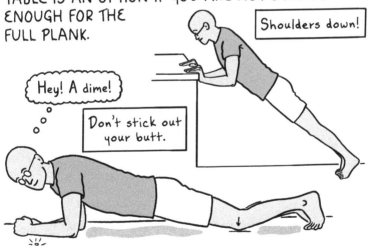

START BY HOLDING FOR 2-10 SECONDS, REPEATING 2-3 TIMES. AS YOU GET **STRONGER** HOLD YOUR PLANK **LONGER.**

CORE STRENGTHENING – THE "BIRD DOG"

YOU CAN **START SLOWLY** BY LIFTING ONLY ONE "PAW" AT A TIME OR **INCREASE DIFFICULTY**. SEE THE NEXT PAGE FOR INSTRUCTION.

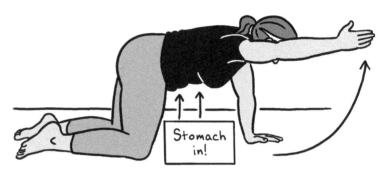

Stomach in!

1. START ON ALL FOURS. INHALE. EXHALE AND LIFT YOUR RIGHT ARM OVERHEAD. HOLD FOR 3-10 SECONDS AS YOU BREATHE NORMALLY. LOWER YOUR ARM. REPEAT TO THE LEFT.

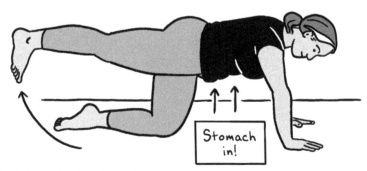

Stomach in!

2. INHALE. EXHALE AND LIFT YOUR RIGHT LEG BEHIND YOU, KNEE STRAIGHT. HOLD 3-10 SECONDS WHILE BREATHING NORMALLY. LOWER YOUR LEG. REPEAT TO THE LEFT.

REPEAT ARM AND LEG LIFTS 1-4 TIMES.

CORE STRENGTHENING – THE "BIRD DOG" (cont'd)

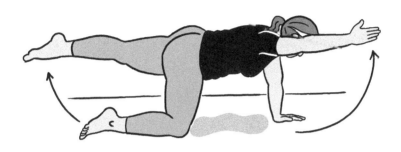

3. WANT A CHALLENGE? INHALE. EXHALE AND RAISE YOUR RIGHT ARM/"FORE PAW" AND LEFT LEG/ "HIND PAW". HOLD AND BREATHE. LOWER THEM. REPEAT WITH THE LEFT ARM AND RIGHT LEG.

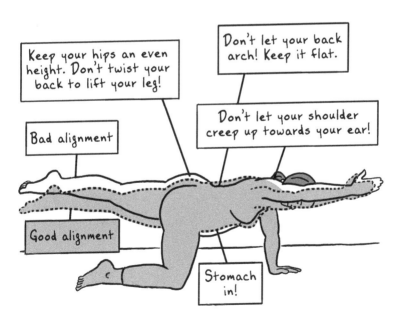

STRETCHES – TORSO STRETCH #1

1. SITTING UP STRAIGHT, →
CLASP BOTH HANDS IN
FRONT OF YOU AT LAP
HEIGHT. KEEP YOUR
ELBOWS **STRAIGHT**.

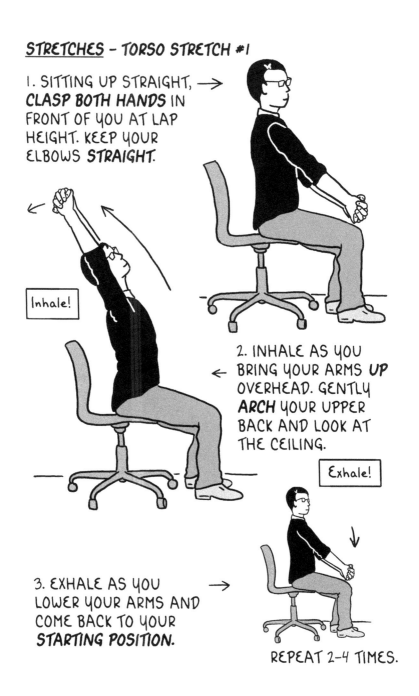

Inhale!

2. INHALE AS YOU
← BRING YOUR ARMS **UP**
OVERHEAD. GENTLY
ARCH YOUR UPPER
BACK AND LOOK AT
THE CEILING.

Exhale!

3. EXHALE AS YOU →
LOWER YOUR ARMS AND
COME BACK TO YOUR
STARTING POSITION.

REPEAT 2–4 TIMES.

STRETCHES - TORSO STRETCH #2

INHALE YOUR ARMS **UP** AND OVERHEAD. **CLASP** YOUR HANDS. EXHALE AND TAKE YOUR CLASPED HANDS TO THE **RIGHT** AS FAR AS YOU CAN GO. INHALE AND **COME BACK** TO YOUR CENTER (STARTING) POSITION. EXHALE AND LEAN TO THE **LEFT**. INHALE RETURNING TO CENTER POSITION.

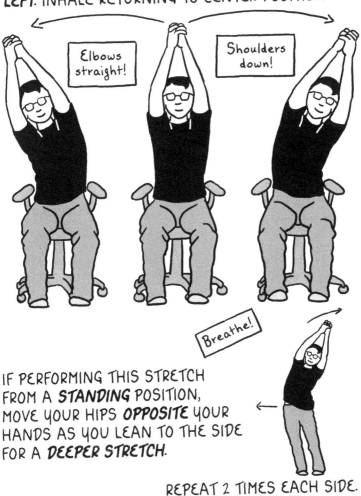

IF PERFORMING THIS STRETCH FROM A **STANDING** POSITION, MOVE YOUR HIPS **OPPOSITE** YOUR HANDS AS YOU LEAN TO THE SIDE FOR A **DEEPER STRETCH**.

REPEAT 2 TIMES EACH SIDE.

HIP STRETCHES – LUNGES

LUNGES STRETCH THE MUSCLES THAT **FLEX** THE HIP. THEY CAN **COUNTER ACT** THE EFFECTS OF **SITTING** ON THE **LOW BACK**.

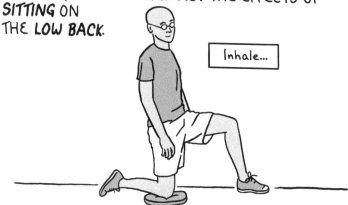

Inhale...

1. KNEEL ON A CUSHION WITH YOUR RIGHT KNEE. PUT YOUR LEFT FOOT ON THE FLOOR IN FRONT OF YOU. INHALE.

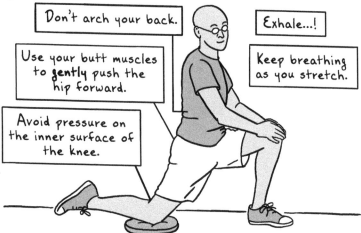

Don't arch your back.

Use your butt muscles to **gently** push the hip forward.

Avoid pressure on the inner surface of the knee.

Exhale...!

Keep breathing as you stretch.

2. EXHALE, SQUEEZE YOUR GLUTEAL MUSCLES AND MOVE THE RIGHT HIP FORWARD, HANDS ON YOUR LEFT KNEE. HOLD FOR 10-30 SECONDS. REPEAT TO THE OTHER SIDE. STRETCH BOTH SIDES 1-2 TIMES.

THIGH STRETCHES – QUADRICEPS STRETCH

QUADRICEPS STRETCHES WILL STRETCH **THIGH MUSCLES** THAT **FLEX** THE HIP. **COMBINED** WITH LUNGES THEY ARE VERY EFFECTIVE AT **REDUCING** BACK PAIN AND/OR TENSION CAUSED BY SITTING FOR LONG PERIODS OF TIME.

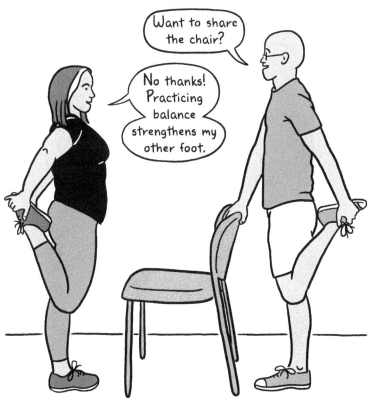

1. USING A CHAIR FOR BALANCE, STAND ON YOUR LEFT LEG. FLEX YOUR RIGHT KNEE AND HOLD YOUR RIGHT FOOT IN YOUR HAND. INHALE. AS YOU EXHALE, GENTLY PULL YOUR FOOT TOWARDS YOUR BUTT. HOLD FOR 10–30 SECONDS. REPEAT TO THE OTHER SIDE. STRETCH BOTH SIDES 1–2 TIMES.

<u>*THIGH STRETCHES – QUADRICEPS STRETCH*</u> (cont'd)

HERE ARE SOME TIPS FOR A GOOD, SAFE QUADRICEPS STRETCH. IF YOU FEEL THE STRETCH IN YOUR THIGH OR YOUR KNEE, IT IS WORKING. THE KNEE AND BACK SHOULD NOT FEEL PAIN!

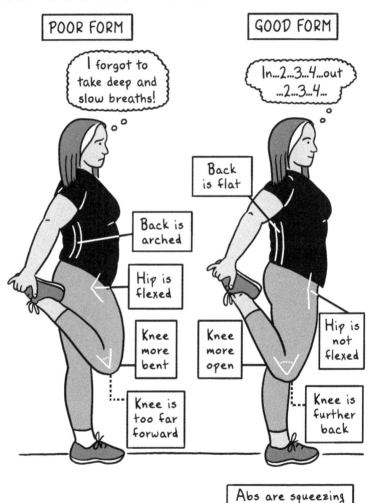

THIGH STRETCHES – QUADRICEPS STRETCH (cont'd)

KEEPING ALIGNMENT IS IMPORTANT. IF YOU CAN **BALANCE** AND **STRETCH** WITH **GOOD FORM**, PRACTICE BALANCING. IF YOU **LOSE** YOUR **FORM** WHEN YOU TRY TO BALANCE, **HOLD ON TO SOMETHING.**

POOR FORM GOOD FORM

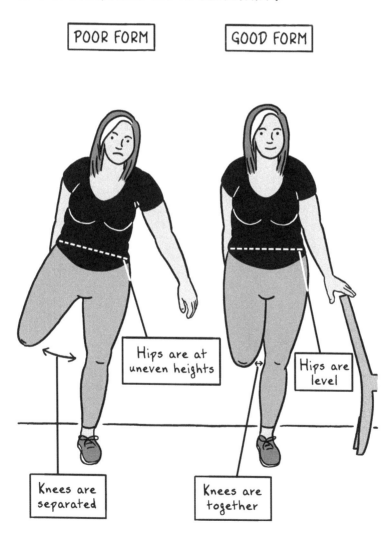

Hips are at uneven heights

Hips are level

Knees are separated

Knees are together

STRETCHES - HAMSTRING STRETCHES

HAMSTRING STRETCHES TARGET THE **BACK OF THE THIGH.** THEY **COUNTERACT** THE EFFECTS OF **SITTING** ON THE **LOW BACK.**

1. LAY ON YOUR BACK WITH YOUR KNEES BENT. INHALE.

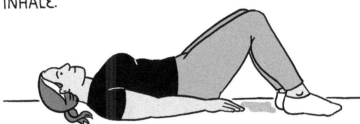

2. EXHALE AND SLOWLY STRAIGHTEN YOUR RIGHT KNEE. USE A TOWEL OR STRAP AROUND YOUR RIGHT FOOT TO PULL YOUR LEG TOWARDS YOUR HEAD.

Hamstrings tight? Straighten your leg as far as you comfortably can. You can still get a good stretch with your knee bent.

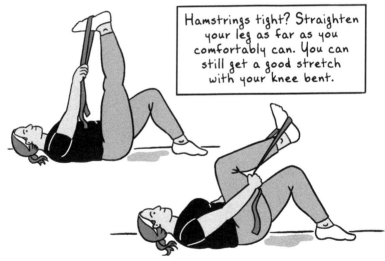

3. KEEP BREATHING. DON'T FLEX (BEND) YOUR BACK AS YOU HOLD THE STRETCH FOR 10-30 SECONDS. STRETCH BOTH SIDES 1-2 TIMES.

Tips and Routines

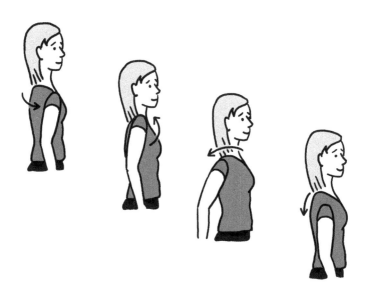

Use these routines during your
drawing day (or night) or you can
make up your own! Feel free to include
favorite exercises not in this book.

SAMPLE ROUTINE #1

WARM UP (About 12 minutes)
- Cardio activities to get your heart pumping. As an example: jog in place 2 minutes, 20 jumping jacks, then jog in place 1 minute.
- Breathing, pp. 87–88
- Plank, p. 91
- Helicopter, p. 76
- Shaking Hands, p. 65
- Finger Spread, p. 70
- Wall Push Ups, p. 67
- Wrist/hand Stretches, pp. 71–72
- Pelvic Rocking, p. 89

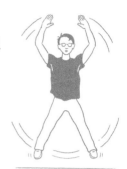

FIRST BREAK (4 minutes)
- Neck Stretch #2, p. 82
- Torso Stretch #2, p. 95
- Jog in place 1 minute
- Pendulum circles, p. 76

SECOND BREAK (2 minutes)
- Shoulder Pulls, p. 77
- Neck Stretch #1, p. 81
- Quadriceps Stretch, pp. 97–99

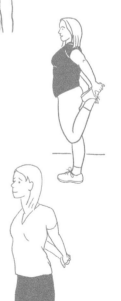

STRETCH AFTER DRAWING (8 minutes)
- Chest Stretch #2, p. 84
- Torso Stretch #1, p. 94
- Lunge Stretch, p. 96
- Wrist/hand Stretches, pp. 71–72

SAMPLE ROUTINE #2

WARM UP (About 12 minutes)
- Put on a fast piece of music and
 dance around for four minutes.
 Get your heart rate up!
- Shoulder Pulls, p. 77
- Side Plank, p. 79
- Squeeze a Towel, p. 68
- Wring a Towel, pp. 68-69
- Wrist/hand Stretches, pp. 71-72
- Neck Stretch #1, p. 81
- Chest Stretch #1, p. 83

FIRST BREAK (3 minutes)
- Shoulder Rolls, p. 75
- Pelvic Rocking, p. 89
- Bird Dog, pp. 92-93
- Jog in place for 1 minute

SECOND BREAK (2 minutes)
- Spider on a Mirror, p. 66
- Shoulder Dips, p. 78
- Pendulum Circles, p. 76
- Shaking Hands, p. 65
- Hamstring Stretch, p. 100

STRETCH AFTER DRAWING (10 minutes)
- Torso Stretch #2, p. 95
- Neck Stretch #2, p. 82
- Wrist/hand Stretches, pp. 71-72
- Quadriceps Stretch, pp. 97-99
- Shaking Hands, p. 65

SAMPLE ROUTINE #3

WARM UP (About 12 minutes)
- Walk around the block as many times as you can in 4 minutes. OR walk up and down a flight of stairs between 2-100 times in 4 minutes.
- Breathing, pp. 87-88
- Slow Crunches, p. 90
- Neck Stretch #1, p. 81
- Quadriceps Stretch, pp. 97-99
- Shaking hands, p. 65
- Squeeze/Wring a Towel, pp. 68-69
- Wrist/hand Stretches, pp. 71-72

FIRST BREAK (3 minutes)
- Dance around for 1 minute
- Pressing in, pressing out, p. 80
- Standing Torso Stretch #2, p. 95
- Shaking Hands, p. 65

SECOND BREAK (2 minutes)
- Quadriceps Stretch, pp. 97-99
- Shoulder Rolls, p. 75
- Neck Stretch #2, p. 82

STRETCH AFTER DRAWING
(10 minutes)
- Hamstring Stretch #2, p. 100
- Chest Stretch #2, p. 84
- Wrist/hand Stretches, pp. 71-72
- Pelvic Rocking, p. 89

Bad Things Can Happen to Good Artists!

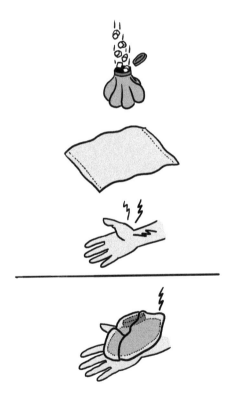

First Aid for Injuries. What R.I.C.E. is and what it does.

SOMETIMES YOU ARE AS **CAREFUL** AS CAN BE BUT GET INJURED **ANYWAY!** NOW YOU'RE FEELING **PAIN**.

MAYBE A **LITTLE**...

MAYBE **A LOT!**

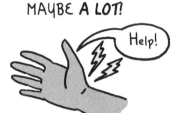

Help!

THERE MAY BE SOME **RED-NESS** AND/OR **SWELLING**...

OR MAYBE NOT.

Help anyway!

BUT YOU HAVE DETERMINED THAT THERE IS **NO MEDICAL EMERGENCY!*** OR YOU HAVE CALLED A **HEALTH CARE PROFESSIONAL** AND WANT TO DO SOMETHING FOR YOUR PAIN BEFORE YOU SEE THEM.

*See pages 10–17.

Can I have some chocolate milk?

No!

REDUCE YOUR PAIN WITH R.I.C.E. THERAPY

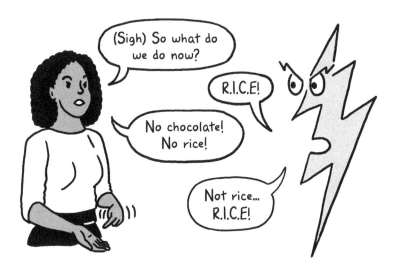

R.I.C.E. STANDS FOR...

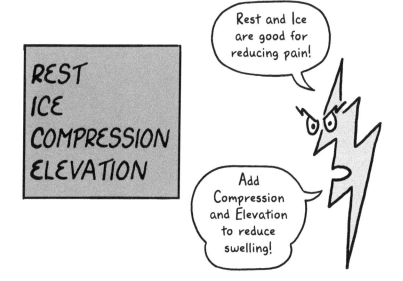

BUT R.I.C.E. THERAPY **WILL NOT** WORK FOR **EVERYTHING.**

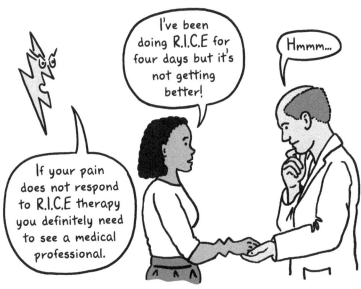

SOMETIMES YOU **DON'T NEED** ALL FOUR STEPS.

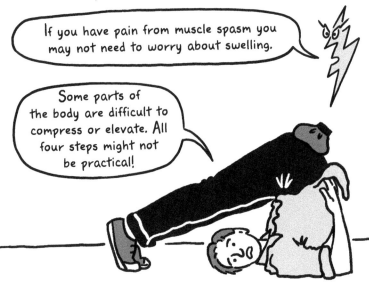

R.I.C.E. Therapy
Step by Step

Tips for maximizing healing.

STEP #1 - *REST!*

GOOD FOR ANY INJURY, **RESTING** THE AREA CAN HELP **REDUCE PAIN** AND **PREVENT** MORE **DAMAGE.**

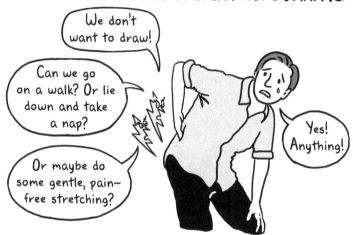

SOMETIMES...

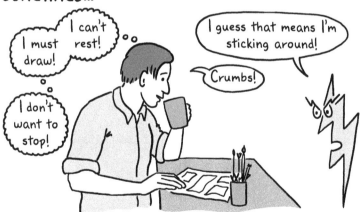

BEWARE! IF YOU **CONTINUE** TO DRAW AND YOUR **PAIN GETS WORSE** YOU MIGHT **INCREASE** DAMAGE TO THE AREA. THIS COULD MEAN **MORE PAIN** AND A LONGER RECOVERY TIME! BUT IT'S **YOUR CHOICE.**

IF YOU **MUST** DRAW IN PAIN, TRY TO **REST** BY **REDUCING STRESS** TO THE AREA.

A) TAKE **FREQUENT BREAKS** (EVEN FOR **MINOR PAIN.**)

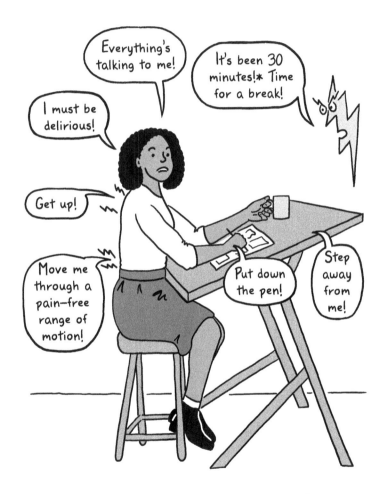

*You will have to experiment to figure out the frequency and length of your breaks. You can set a timer to remind you to rest.

B) **STOP** DOING OTHER **PAINFUL** ACTIVITIES OR DO THEM **LESS FREQUENTLY**. THESE MIGHT INCLUDE...

TEXTING,

COMPUTER WORK,

WRITING OR SKETCHBOOK TIME,

CARRYING HEAVY OBJECTS,

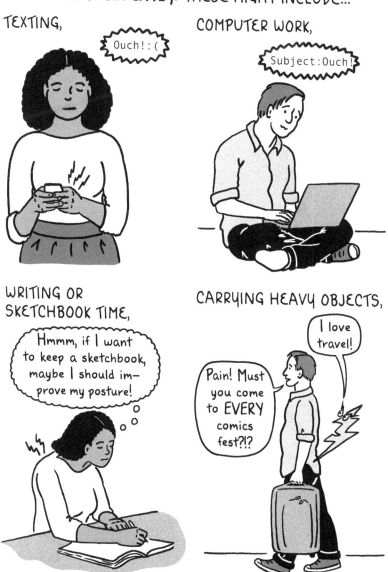

OR ANYTHING ELSE THAT **CAUSES YOU PAIN.**

STEP #2 - *ICE*

ICE APPLICATION HELPS TO...

REDUCE MUSCLE *SPASM*,

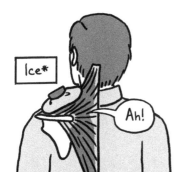

REDUCE PAIN BY NUMBING THE AREA,

AND *CAUSE VASOCONSTRICTION***

...WHICH HELPS TO *CONTROL INFLAMMATION* AND *SWELLING*.

*Ice should be wrapped in a towel!
**Narrowing of blood vessels.

GUIDELINES FOR **APPLYING ICE:**

A) ALWAYS **FOLLOW LABEL DIRECTIONS** WHEN USING **CHEMICAL** COLD PACKS. (IF YOU DON'T YOU COULD GET **FROSTBITE!**)

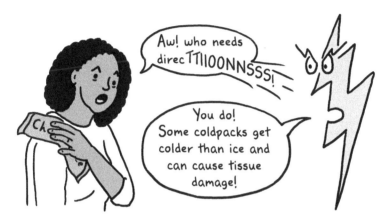

B) **ICE CUBES** OR **CHIPPED ICE** IN A PLASTIC BAG OR REUSABLE ICE BAG WORK, TOO!

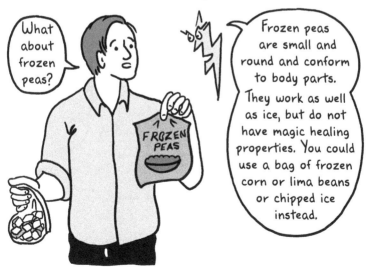

C) **WRAP** ICE IN A **TOWEL** BEFORE APPLICATION.

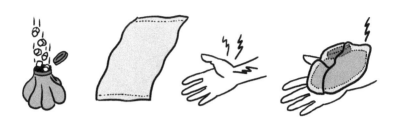

D) APPLY ICE TO THE AREA **UNTIL IT'S NUMB,** BUT NO LONGER THAN **20 MINUTES MAX!** (OR YOU COULD GET **FROSTBITE!**)

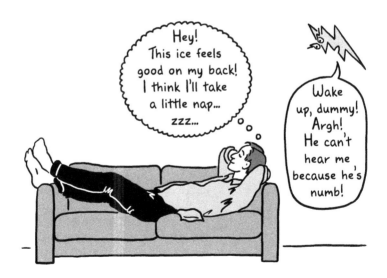

E) **DON'T FALL ASLEEP ON AN ICE PACK!** REMEMBER THE **20 MINUTE RULE!**

F) CAUTION! IF YOU'RE **ALLERGIC** TO ICE, ***DON'T ICE!***

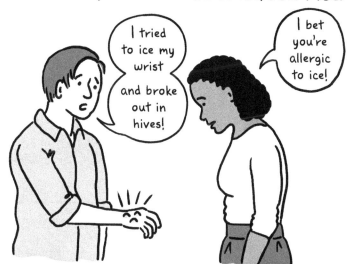

G) ***CAUTION!*** IF YOU HAVE ***IMPARED CIRCULATION*** OR SUFFER FROM ***REYNAUD'S PHENOMENON*** OR HAVE ***ANY OTHER*** ICE-ADVERSE CONDITION, ***DO NOT ICE*** UNLESS YOUR ***DOCTOR*** SAYS IT'S OKAY! CHECK IN WITH YOUR DOCTOR ABOUT ***COMPRESSION***, TOO!

*DO NOT ATTEMPT! Orthodpedists are NOT amused by jokes about Frozen Shoulder, a.k.a. Adhesive Capsulitis.

HEAT IS GOOD AT **REDUCING MUSCLE SPASM** AND **REDUCING PAIN.** BUT HEAT IS A **VASODILATOR.** IT CAN BRING MORE BLOOD INTO THE AREA. THAT CAN LEAD TO **SWELLING** OR IT CAN **INCREASE SWELLING.**

IF YOU HAVE AN **INJURY** WITH **INFLAMMATION OR SWELLING,** CONSULT A **HEALTHCARE PRACTITIONER** BEFORE APPLYING HEAT. IF YOU **DON'T KNOW** IF YOU HAVE INFLAMMATION, PLAY IT SAFE AND **APPLY COLD.**

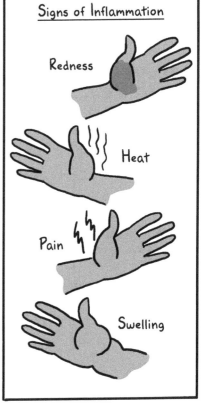

STEP #3 - *COMPRESSION*

COMPRESSION **REDUCES** PAIN AND SWELLING.

SOME PEOPLE **LIKE** THE FEELING OF **SUPPORT**.

SOME PEOPLE USE IT WITH **ICE**.

SOME PREFER COMPRESSION **AFTER** ICING.

BEWARE: IT MAY **NOT** BE RIGHT FOR **SOME AREAS**.

COMPRESSION CAN **REDUCE MOVEMENT** AT JOINTS AND MAY HELP **IMPROVE ALIGNMENT**, POTENTIALLY **REDUCING PAIN**.

IMPORTANT! USE **ELASTIC** TAPE, SLEEVES, OR CUFFS. DON'T **WRAP** TOO **TIGHTLY.** IF THE **DISTAL** (FAR) SIDE OF THE COMPRESSED AREA TURNS **RED, BLUE,** OR **SWELLS,** IT IS **TOO TIGHT!!!!**

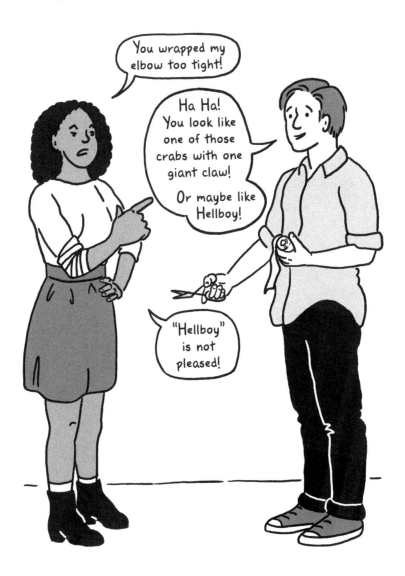

STEP #4 – *ELEVATION*

ELEVATING AN INJURY *ABOVE HEART LEVEL* WILL HELP TO *DRAIN* IT, *REDUCING* SWELLING AND PAIN.

ODDS ARE THAT A *DRAWING* INJURY WILL *NOT* INCLUDE A DRAMATIC AMOUNT OF *SWELLING*. BUT *YOU NEVER KNOW...*

FOR **MINOR PAIN,** R.I.C.E. THERAPY MAY BE **ALL** THE HELP YOU NEED...

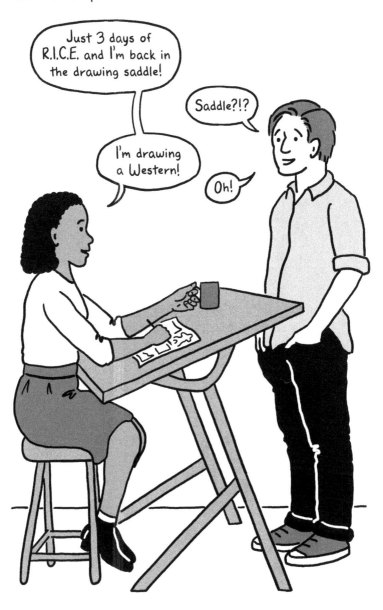

...BUT **DON'T** CONFUSE **R.I.C.E.** THERAPY FOR **MEDICAL** TREATMENT IF YOU **NEED IT!**

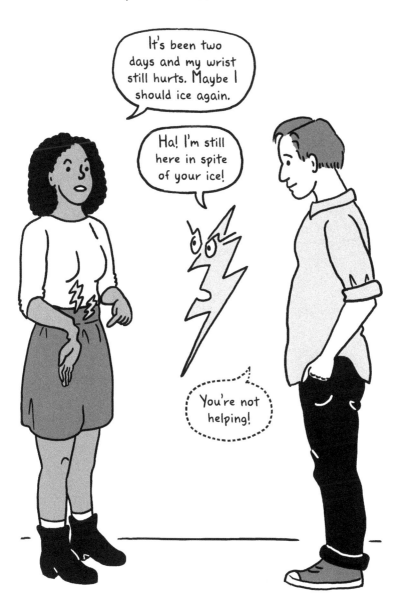

More Ways to Reduce Pain

Other common pain treatments.

R.I.C.E. THERAPY IS ONE WAY TO TREAT AN INJURY, REDUCING PAIN, INFLAMMATION, AND SWELLING. WE WILL ALSO REVIEW OTHER WAYS TO TREAT PAIN BUT NOT NECESSARILY TREAT YOUR INJURY.

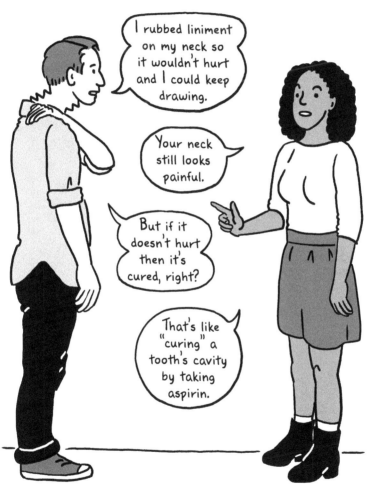

REDUCING OR MASKING PAIN AND TREATING THE UNDERLYING CAUSES OF INJURY MAY NOT BE THE SAME THING.

IF YOU **REDUCE** YOUR PAIN WITH **ICE, HEAT,** OR ANY OF THE FOLLOWING **"REMEDIES"** AND **CONTINUE DRAWING** OR PERFORMING OTHER PAINFUL **ACTIVITIES** WITHOUT **REST,** YOU RISK **MAKING YOUR INJURY WORSE.**

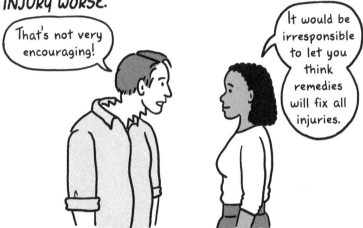

That's not very encouraging!

It would be irresponsible to let you think remedies will fix all injuries.

REMEDIES AND **OTHER TREATMENTS** CAN BE **USEFUL TOOLS** FOR REDUCING PAIN WHILE YOU **REST** (AND PERHAPS SEEK **PROFESSIONAL** EVALUATION AND TREATMENT FOR YOUR INJURY.)

Is that more encouraging?

Sort of.

ON TO OTHER METHODS FOR REDUCING PAIN...

LINIMENTS LIKE TIGER BALM, ICY HOT, OR BENGAY HELP TO **BLOCK** YOUR PAIN BY SENDING A STRONG **ALTERNATIVE SENSATION** TO YOUR BRAIN. OR AT LEAST THAT'S THE **THEORY** OF HOW THEY WORK.

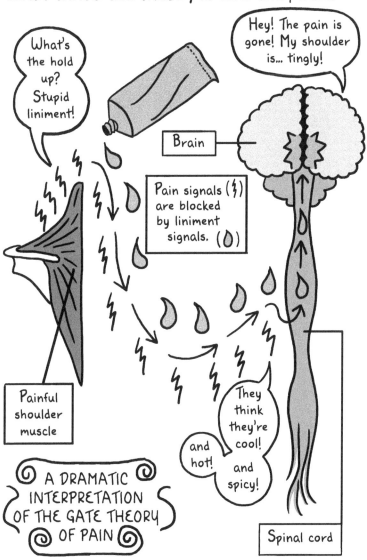

RECIPES FOR OTHER REMEDIES THAT YOU CAN MAKE AT HOME MAY BE **HELPFUL, INEFFECTIVE,** OR **HARMFUL.**

CAREFUL! "NATURAL" INGREDIENTS CAN BE AS POTENT AS **"UNNATURAL"** ONES! **ASK A QUALIFIED HEALTHCARE PROFESSIONAL ABOUT THE EFFICACY AND/OR SAFETY OF PARTICULAR HOME REMEDIES.**

HOMEOPATHIC AND HERBAL REMEDIES MAY REDUCE YOUR PAIN – OR NOT! SOME (BUT NOT ALL) HERBS HAVE BEEN PROVEN CLINICALLY TO BE HELPFUL. USE CAUTION!

I took a homeopathic tendinitis remedy, now I'm drinking garlic, ginger, and lemon tea for inflammation.

Last night I rubbed arnica creme on my wrist but today I will use calendula instead.

Can I borrow $20?

Um... I'm broke.* But you can use some arnica creme. It cost me $20!

PAY ATTENTION TO YOUR BODY. DOES A REMEDY ACTUALLY REDUCE YOUR PAIN AND SYMPTOMS? IF YOU USE TOO MANY REMEDIES AT ONCE YOU WON'T KNOW WHICH ONE WORKED AND WHICH DID NOT.

*"Natural" is not another word for "harmless" but it can be another word for "EXPENSIVE!" Spend your money wisely!

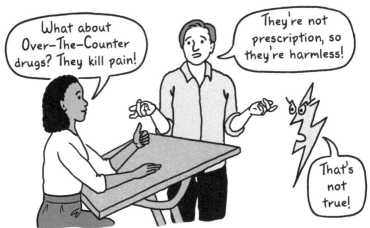

HERBS AND O.T.C. DRUGS HAVE SERIOUS **SIDE-EFFECTS!** THEY CAN **INTERFERE** WITH **PRESCRIPTION DRUG** ACTIONS. IF YOU HAVE OTHER **HEALTH CONDITIONS** CONSULT YOUR DOCTOR BEFORE TAKING THEM. **ALWAYS FOLLOW LABEL DIRECTIONS.**

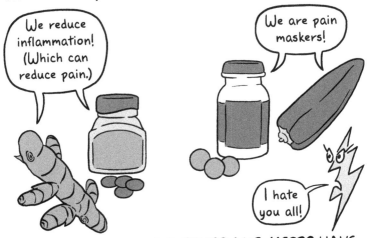

DIFFERENT PAIN-KILLING **DRUGS** AND **HERBS** HAVE **DIFFERENT WAYS** OF **AFFECTING THE BODY.** DON'T **ASSUME** THEY ARE TREATING YOUR **INJURY** AS THEY TREAT YOUR **PAIN.**

The End?

Select Bibliography of Interesting, Informative, or Trivial
(but entertaining) Online Reading
COMMENTS IN CAPITAL LETTERS

Bass, Evelyn. "**Tendinopathy: Why the Difference Between Tendinitis and Tendinosis Matters.**" International Journal of Therapeutic Massage & Bodywork. March 31, 2012. https://www.ncbi.nlm.nih.gov/pmc/articles/PMC3312643/ (2016). WELL-WRITTEN ARTICLE ARTICULATING THE DIFFERENCES BETWEEN TENDINITIS AND TENDINOSIS, DESCRIBING SYMPTOMS OF BOTH, AND TREATMENT OPTIONS FOR MASSAGE THERAPISTS WORKING WITH THESE PATIENTS.

Gate Control Theory. Wikimedia. February 12, 2015. http://en.wikipedia.org/wiki/Gate_control_theory (March 23, 2015). GOOD PRESENTATION OF A THEORY CONJECTURING HOW PAIN SIGNALS GET BLOCKED BY OTHER STIMULI (SUCH AS FROM LINIMENT).

Liebert, Paul. *Approach to Sports Injuries: Treatment.* October 2014. http://www.merckmanuals.com/professional/injuries_poisoning/sports_injury/approach_to_sports_injuries.html?qt=sports%20injuries&alt=sh (March 23, 2015). STANDARD R.I.C.E. TREATMENT.

Martin Universal Design, Inc. **Susan Scheewe Portable Art Studio– 16" x 21".** http://www.martinuniversaldesign.com/U-SS1621B/ (April 7, 2015). PORTABLE ADJUSTABLE HEIGHT DRAWING DESKS CAN BE VERY HELPFUL FOR IMPROVING POSTURE. I'M NOT ENDORSING M.U.D. INC. YOU CAN START HERE FOR PRICING. MANY ART SUPPLY STORES, EBAY, AND AMAZON CARRY THEM.

Mayo Clinic staff. *Diseases and Conditions: Herniated Disk.* Jan 28, 2014. http://www.mayoclinic.org/diseases–conditions/herniated-disk/basics/definition/CON-20029957?p=1 (2016). EXCELLENT AND THOROUGH ARTICLE.

Memorial Sloan Kettering Cancer Center. **About Herbs, Botanicals & Other Products.** 2016. Aboutherbs.com (2016). EXCELLENT RESOURCE ABOUT HERBS AND HERBAL RESEARCH. EMPHASIS IS FOR CANCER PATIENTS BUT THEY COVER OTHER USES AS WELL.

Moayedi, Massieh, and Karen D. Davis. **"Theories of pain: from specificity to gate control."** Journal of Neurophysiology. American Physiological Society. January 1, 2013. http://jn.physiology.org/content/109/1/5 (March 23, 2015). READ UP ON THE HISTORY OF PAIN THEORIES. FUN!

U.S. National Library of Medicine. **Sprains and Strains.** September 9, 2014. https://medlineplus.gov/sprainsandstrains.html (2016). GREAT SITE WITH LOADS OF INFORMATION. I LOVE THE NLM!

United States Department of Labor. Occupational Safety & Health Administration. **Ergonomics eTool: Materials Handling: Heavy Lifting.** https://www.osha.gov/SLTC/etools/electricalcontractors/materials/heavy.html (2016). LOTS OF HELPFUL LIFTING TIPS HERE. DISREGARD THE FORKLIFT INFORMATION UNLESS YOU HAVE ACCESS TO ONE!

van den Bekerom, Michel P. J., A. A. Struijs, leendert Blankevoort, Lieke Welling, C. Niek van Kijk, and Gino M.M.J. Kerkhoffs. **"Journal Of Athletic Training — What is the Evidence for Rest, Ice, Compression, and Elevation Therapy in the Treatment of Ankle Sprain in Adults?"** PMC US National Library of Medicine National Institute of Health. August 2012. http://www.ncbi.nlm.nih.gov/pmc/articles/PMC3396304/ (March 23, 2015). SYSTEMATIC REVIEW OF R.I.C.E. STUDIES. GREAT DESCRIPTIONS OF R.I.C.E. ALTHOUGH THEY DID NOT FIND IT AN EFFECTIVE TREATMENT. (IT'S STILL THE BEST FIRST AID TREATMENT WE HAVE, IN MY OPINION.)

Kriota Willberg uses comics, needlework, historical studies, bioethics, and her experiences from her career as a massage therapist and health science educator to explore body/science narratives. As a massage therapist, she focuses on the treatment of orthopedic injuries and has worked with populations ranging from the New York Giants football team to patients at Memorial Sloane Kettering Cancer Center. Combining this history with her background as an artist and educator, she has been creating comics and teaching artists about injury prevention through panels, workshops, and a series of minicomics, now combined with additional materials into *Draw Stronger*. Her other comics appear in: *4PANEL*.ca, *SubCultures*, *Awesome Possum*, *Comics For Choice*, *The Strumpet*, *The Graphic Canon*, as well as the journals *Intima* and *Broken Pencil*. Willberg is the inaugural Artist In Residence at the New York Academy of Medicine Library. She lives in New York with her husband, R. Sikoryak, and two cats.

For more: KriotaWelt.blogspot.com.